The Writer's Image

The Writer's

Literary Portraits by

Image

JILL KREMENTZ

Preface by KURT VONNEGUT
Introduction by TRUDY BUTNER KRISHER

David R. Godine, Publisher · Boston

The Writer's Image

January 1981

First published in 1980 by

David R. Godine, Publisher, Inc.
306 Dartmouth Street
Boston, Massachusetts 02116

LIBRARY OF CONGRESS CATALOGING IN PUBLICATION DATA

Krementz, Jill.
The writer's image.

1. Authors, American–20th century–Portraits.
2. Authors–20th century–Portraits. I. Title.
PS137.K7 779'.2'0924 80-66461
ISBN 0-87923-349-4

MANUFACTURED IN THE UNITED STATES OF AMERICA

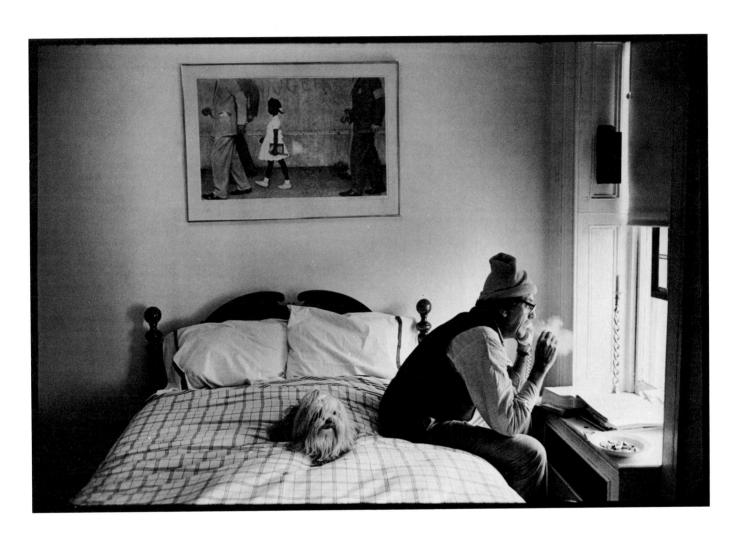

For Kurt, of course.

Preface

'Jill is something quite new in the history of photography, so far as I know. She is a totally self-contained photo-journalistic unit — the writer, researcher, photographer, and business representative, all in one. All she needs is a secretary to file things for her.'

— KURT VONNEGUT

LOOK AT THE JACKET of most American books published before 1970. Why is the picture of the author so grainy? Why is the author squinting so? Why does the picture look so much like a picnic snapshot? Why do these publicity shots look like the best picture a morning newspaper could find of a person who died in a head-on collision the previous evening?

Answer: Until very recently, publishers were as interested in portraiture as the Passport Division of the Department of State — not at all.

Jill Krementz changed all this.

Long before I met her, she was offended by how charmless and uninformative were the pictures on most book jackets. Fortunately, she knew what could be done about it, for she was already a well-established photo-journalist, with two books of her own behind her. She already knew the technique of catching a likeness and telling something about a subject's life and character in a single photograph.

So she began photographing authors on her own, hoping to show both authors and publishers what was possible and, God willing, even desirable. What was very much against her was that a good photograph would add to the cost of a book. But it was a cost publishers soon decided they could neither ignore nor bypass; a good portrait was as crucial to selling a book as good copy. Publishers and authors now care as much about the jacket portrait as they do about a book's binding, paper, typesetting, and overall design.

For Jill, photography is a craft, and if I speculate about that craft's possible artistic dimensions, I do so with little encouragement from her. My impulse has been to compare photographers with painters, and to speculate about their similarities and differences.

I now think that it is more useful to compare portrait photographers, at least, with actors, and especially highly intelligent clowns, instead. Really. The most successful portrait photographers, I am now persuaded, get their subjects to reveal their inner selves by entertaining them as though they were children. This has to be done briefly, of course, during those decisive moments when the shutter is being clicked again and again.

Jill herself dances and smiles as she actually exposes film, but *not* while she is preparing to do so. And I am sure that every other successful portraitist has a similarly innocent, whimsical, inane little act that is concealed from the subject until the moment of truth.

Every portrait that Jill takes, in any event, is of a person tricked out of his or her shell by a sweetly surprising, unthreatening, and momentarily entertaining social situation.

Hey presto!

As for enterprise: she has photographed nearly one thousand authors. She has never, however, photographed a person unwilling to be photographed; and once images of a person are in her files, the images themselves are given a sort of privacy. She refuses to submit entire contact sheets to an editor, but shows only those pictures that represent the subject at his or her best. Moreover, she will not sell a picture if it is to illustrate an attack on the subject.

This moral code has no roots in anybody else's essay on ethical standards for photographers. It is a pretty invention all her own.

Yes, and she has caught plenty of hell from editors, who are accustomed to selecting what they please from a photographer's entire take and to being the final judges as to whether someone is made to look like a fool or a rumdum or a swindler or not.

She has caught hell again for insisting on behalf of all photographers that their copyright notice appear right along with their pictures, and not in some little box in the back of a publication, and for collecting damages if her copyright notice is

omitted, and for threatening suit or even suing when someone prints one of her pictures without permission.

And I would have minimal respect for professional photographers even today, even though I am now married to one, if it weren't for this: Modern cameras have become the most cooperative of all modern machines. There are millions upon millions of them in the world — and yet, the vast majority of pictures aren't worth looking at twice. When a good picture has been taken, a human being has worked a small miracle, has humanized a machine.

The machines Jill uses, by the way, are a Leica M4[2] with a 35-mm lens, and a Nikon FM with an 85-mm lens. Occasionally she uses a 21-mm lens on her Leica. That is it, except for a little Olympus, really a tourist's pocket camera, of which she is growing increasingly fond. I wish there were more equipment to describe. She is pathetically under-equipped, and I have offered to bring her armamentarium up to strength at the approach of every birthday or Christmastime. But she says there is nothing she needs.

There are more details, which I set down in her words: 'I generally use Tri-X film for black and white photographs and Kodachrome 64 for color — unless I am bringing lights, in which case I will use Kodachrome 25 ASA.'

She almost never brings lights, says she can photograph in black and white anything she can see, likes the light one hour before sunset best of all, and rarely spends more than an hour photographing a subject. That isn't one hour from the time she has set up. That is one hour from the time she has said 'hello' until she says 'goodbye.'

She has photographed a lot more than simply writers, of course. She was chosen, for example, to take the official photographs of four cabinet members in the Carter Administration — including the Secretaries of State and Defense. Curiously, the portfolio she submitted, and which won her the assignment, consisted of only three black and white portraits: W. H. Auden, Truman Capote, and Doris Lessing.

Her particular heroine when she was young was Margaret Bourke-White, the *Life* photographer. But the golden era of *Life* magazine as a weekly was over by the time Jill was ready to go to work for it. She has found a way to do photographic

essays anyway, in the Margaret Bourke-White tradition—by putting them into hardcover books. The books, in fact, allow her far more space for telling her stories than the old *Life* ever could have provided.

She does work for the new *Life*, incidentally, the monthly version—and is on the masthead of *People*, and appears regularly in *Time* and *Newsweek* and *The New York Times*, and on and on.

Other wives may tell their husbands of former beaux. Mine talks about the picture editors who taught her how to use her first Nikon, the one who hired her as the first woman photographer on the old *Herald Tribune*, the one who sent her to cover the 1964 Harlem riots with Jimmy Breslin, and on and on.

I am most respectful.

I work on the top floor of our house, she works on the bottom floor, and we share the two floors in between. And it would be nice to be able to say that I have helped her career in many ways. But advising Jill at 30, her age when I met her, would have been like advising a pinwheel at the peak of its velocity and display.

To put it another way: only fireworks are as self-propelled as Jill was then, and remains today.

<div align="center">

KURT VONNEGUT
New York City
1980

</div>

Introduction

SHE DESCRIBES HER ADVENTURES as 'the most wonderful English course in the world.' But Jill Krementz has not used the predictable materials of pen, paper and books. Instead, she has studied twentieth-century writers with lens, camera and light.

Jill Krementz is the world's foremost photographer of writers. Much of her work is preserved in permanent collections of the Library of Congress, the Museum of Modern Art, and the Delaware Art Museum. Her pictures regularly grace the pages of *The New York Times*, *Newsweek*, *Life*, *Time*, *People*, *New York* and other major periodicals.

Her subjects read like a Who's Who of Twentieth-Century Literature: Saul Bellow, John Cheever, Truman Capote, Doris Lessing, Norman Mailer, Lillian Hellman, Gore Vidal. *The Writer's Image* is a collection of over one hundred of those photographs. It is a moving display of an artist looking at other artists.

'I can't imagine a civilization without writers,' Krementz says, her voice, like her photographs, both soft-spoken and articulate. She began photographing authors because she felt writers were being done a disservice. Authors would create masterpieces and the publicity departments at their publishing houses would say, '"Send us your bio form and two or three snapshots of yourself," and they would go rummaging through their children's wallets or would have their neighbor take their picture. Usually whoever was taking the picture thought the sun should be over his left shoulder, which meant it was shining directly in the subject's eyes. The outcome was a generation of squinty photographs. I thought they deserved a little better.'

One of her earliest subjects was Peter Benchley, a personal friend for whom she took a dust jacket photograph. But Krementz had discovered a need that meshed with her own personal style. 'Nobody was doing writers,' she says, 'and I

was more comfortable working in an area by myself where there's no real crowd situation. I like to be able to step back or move to the right to get a better-composed photo. You can't do that when you're in a group of twenty photographers, all jostling for position.' Writers were 'a group I admired and respected. The more I did, the more I knew, the more I could bring to the photograph.'

What she brings to her photographs is an intelligent blend of the classic and the contemporary. Her portraits of Eudora Welty and E. B. White, for instance, are stunning samples of the Krementz signature. Welty's head, silhouetted against her bedroom window, suggests a Greek bust in profile, yet in the foreground is the author's unmade bed. The portrait of White, taken in his beloved boathouse, employs a stream of light through an open window, evoking paintings by the Dutch masters, yet the spare, spartan setting is distinctly contemporary.

Her conversation is filled with anecdotes about the writers she has studied through her viewfinder. S. J. Perelman revealed that his Algonquin Roundtable colleagues regularly held birthday parties for their dogs, complete with paper hats and birthday cakes. Katherine Anne Porter, whom Krementz snapped in bed, confessed that, 'Honey, I never get out of it. I only got up because you were coming.' P. G. Wodehouse, she found, was an *Edge of Night* addict; he wouldn't pose until the day's episode was over. When asked if she had ever been married, Janet Flanner astonished Krementz: 'I'm sure I have,' Miss Flanner replied, 'but the precise details of the union quite escape me.'

And although she can't pinpoint a favorite photograph, she confesses that photographing E. B. White was her most exciting prospect. 'I couldn't sleep,' she says. 'I was like a kid waiting for Christmas. Ten more days, nine, eight . . .'

Ironically, she almost missed the opportunity. At the last minute, 'He called me and said, "I don't think you should bother coming. I'm too old for this kind of thing."

' "Too old!" ' she exclaimed. ' "I've just taken P. G. Wodehouse who's 93, and Rex Stout who's 86 — and you're about twenty years younger than either of them!" ' White acquiesced, and her portraits of him in his boathouse and in the barn where Charlotte wove her web are among her treasures.

And 'certainly Nabokov' was a thrilling prospect. Krementz, for whom punctuality is a point of professional pride, almost missed her appointment with him. She intended to fly to Switzerland by way of Paris, but an air strike delayed her plane for two hours. Her session with Nabokov, scheduled for three, was in danger of forfeiture. There were speeding taxicabs, breathless sprints, and a panting photog-

rapher who rushed into the lobby of the Montreux Palace Hotel 'just as the chimes were bonging three.'

Nabokov was hungry for gossip about writers in the States, she remembers. 'He was particularly interested in Salinger. So when I told him that Salinger was infatuated with a young writer who was only nineteen or twenty at the time, his face lit up and he turned to his wife: "So, Vera – just like Lolita!"' As Krementz notes, 'It was a pure case of life imitating art.'

Krementz prepares for her sessions with the diligence of a graduate student. She always reads at least one work by the author, often more. Before a session with Henry Miller, for example, she spent more than a hundred dollars on his writings. And her photograph of Eudora Welty was enriched by her reading of *The Optimist's Daughter*. The wooden cabinet that figured in the story can be seen to the right of the photograph.

Krementz, who has earned the sobriquet 'the writer's photographer,' strives for a relaxed, natural setting in her compositions, preferring to capture her subjects at home. 'I think it is very important for the subject to be relaxed, even happy. For that reason I prefer not to use a tremendous amount of equipment. Lights, tripods, all the paraphernalia of the "professional" has the effect of turning the session into a stilted portrait sitting. I am not going after the formal portrait. I am after the story, the reportage.

'Of *course* I set them up,' she says when discussing the poses her subjects take. The picture of Anaïs Nin is a case in point. 'I didn't just happen to find her in Washington Square Park sitting like that,' referring to the striking composition of Nin on the grass, enveloped in a cape like a black cocoon. 'I also took care to get rid of all the Good Humor wrappers.' Inexperienced photographers, she says, 'will go all the way to California to get a picture and then not walk across the room to move a lamp three inches to the left.'

In analyzing her own style, Krementz says she strives for 'an emotional situation in my pictures.' Emotion, that is, 'within a very tight structure of composition and light. I come from a painting background. I love light and like to use a Vermeer kind of lighting.'

Patience is important, too. 'You learn to wait for the exact second.' The novice is 'too excited to get just an image on film.' To Krementz, the three most important words in a photographer's vocabulary are *The Decisive Moment*.

'But what I care most about is the element of trust between me and the person I'm photographing. What I try to do is show the private side of people without

violating their privacy. I think there is a line here you cannot cross. But I also think that the closer you can approach it, the more successful the photograph will be.'

She so respects the privacy of her subjects that when William Shawn, camera-shy editor of *The New Yorker*, haltingly, modestly asked her to take his photograph, she promised that 'we'd keep it in a vault somewhere until his death' if he wished, or preserve it for posterity if he wanted.

And of J. D. Salinger, one of the few writers she hasn't photographed, she says that, 'When someone called me up and said they knew where he'd be at such and such a time, I wouldn't even consider it. I respect his privacy too much.'

On the subject of privacy, she adds: 'A far more difficult problem for me is whether it is acceptable to take pictures on social occasions, among friends. Being a photographer and living in New York means I know a lot of writers. When I go out, I often have a little Olympus camera with me, a sort of snapshot camera. If I go over to Norman Mailer's and Norris Church's for dinner, it's fun to take a picture of Norman cooking his special broccoli in a wok. But I feel I am there as a private person and as a friend, and I do not want to violate a friendship by taking photographs. These are photographs for my personal photo album and for theirs.

'And yet it's ironic. If a photograph that a writer expected to be private becomes public, he will be quick to say, "I didn't know you were here professionally." But as a writer, he feels perfectly free to use his friends' personalities, physiognomies, and conversations in his books! Where's the difference? In a way, I feel that ethically I am operating in an area that is at least more overt because I cannot possibly take a picture without my camera; but a writer's ears are always silently recording for posterity.'

Is photography an art or a craft? 'Despite my background in art,' she says, 'I think of my photography as being more a craft. I have never really thought of my photographs as art in the sense that, for instance, Ansel Adams's photographs are.' But she does think that her work – 'especially the photographs of writers – has great value as an archive. My files are totally organized, and if I were to die tomorrow, anybody walking into my office could find cross-indexed photos of any person I have ever photographed. In my own collection, I have pictures of many of the same people, taken over the years. You can see them changing; sometimes they look better, sometimes worse. But always different.'

Jill Krementz came to photography on the way to a career in journalism. The daughter of a jeweler in Morristown, New Jersey, she spent some time at Drew

University as an art major before coming to New York and a secretarial job at *Harper's Bazaar* for $59.50 a week. In 1961, after a period at *Glamour* magazine, she traded her sewing machine in on a Kodak Brownie and took off – on a shoe-string – for a trip around the world.

On her return she landed a job at *Show* magazine. 'My first real mentor was Henry Wolf, the art director at *Show*. I had been given a Nikon for my twenty-first birthday, in 1961, and all the directions were in Japanese – even the roll of film had Japanese directions. I went to see Henry and showed him this wonderful new toy and asked him if he would help me load it. He told me it was like having a beautiful Rolls Royce and not knowing how to drive! Nevertheless, he loaded it for me and off I went to the zoo like every other fledgling photographer who ever lived.'

In 1962, Ben Price of the *New York Herald Tribune* hired her on as the paper's first female staff photographer: she's been a professional photographer ever since.

But 'the person who really taught me the most about photography was Ira Rosenberg, another staff photographer at the *Tribune*. He showed up every day with the same enthusiasm I did. If I was feeling proud because I had gotten a picture on the front page that day, he was always very quick to say, "That's yesterday's paper. People are already wrapping their fish in it. What are you going to do tomorrow?" This had an enormous influence on my general outlook on life. It would have been very tempting and easy to keep on photographing writers forever, instead of moving on to other projects. But I think I subconsciously could hear Ira saying, "Okay, you've made it as a photographer of writers. What are you going to do next?"'

In 1965 she took a leave from the *Trib* to do a book on Vietnam. *The Face of South Vietnam*, with text by NBC correspondent Dean Brelis, was a backstage look into the drama of a nation at war. In 1969 she produced *Sweet Pea – A Black Girl Growing Up in the Rural South*, a documentary album about ten-year-old Barbara Anderson with whom Krementz lived for several weeks. She prepared for this project by studying anthropology with Margaret Mead, 'another person who was very influential in my career. Dr. Mead showed me how important it was to be persistent, that it was the only way one would ever accomplish anything.' The last several years have seen Krementz's series of *Very Young* books for children: *A Very Young Dancer*, *A Very Young Rider*, *A Very Young Gymnast*, *A Very Young Circus Flyer*, *A Very Young Skater*.

'It's always the pictures that I'm going to take tomorrow that are the hardest.

I know at this point in my career that I'll always try to do a competent job, but I try to go beyond competence—I try to do something that is really special. For instance, I went to photograph William Buckley in his New York brownstone. At the end of the session I remember thinking I had a lot of nice portraits. But I did not feel that I had taken a *special* photograph, a photograph that any one of ten other competent photographers could not have taken. Buckley was going over to a television studio to do an interview and said I could come along. So I popped into the front seat with the chauffeur and that is when I took the picture of him talking on the car phone, with the dog draped over the back seat.'

The Writer's Image is a collection of those 'special' photographs. In it, the camera of Jill Krementz captures the images of the men and women who have shaped the images of modern literature. It is the creation of a woman who, like her camera, is constantly on the move, experimenting, probing, investigating new ideas, new subjects. 'I love moving on to new areas,' she says, 'stretching my muscles, growing. I am grateful for a career that allows me to take enormous risks.'

The Writer's Image is evidence of the fact that Jill Krementz accomplishes the tasks she tackles with grace, intelligence, talent. E. B. White was on target when he autographed her picture of him: 'For Jill, the relentless.'

TRUDY BUTNER KRISHER
Dayton, Ohio
1980

The Photographs

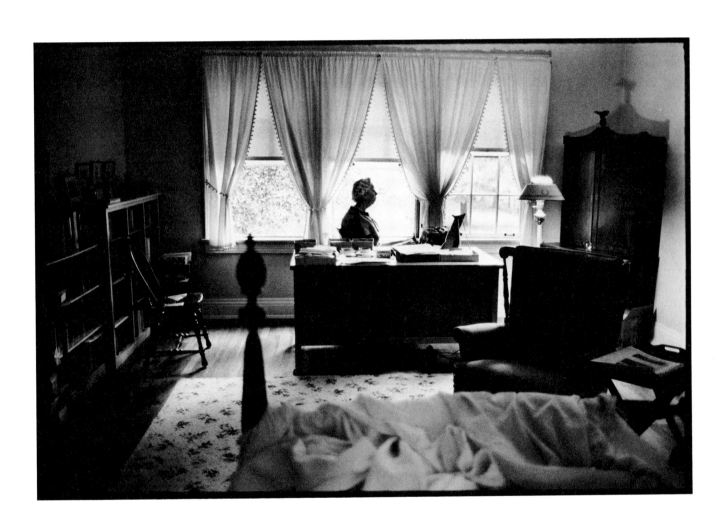

EUDORA WELTY

Jackson, Mississippi, 1972

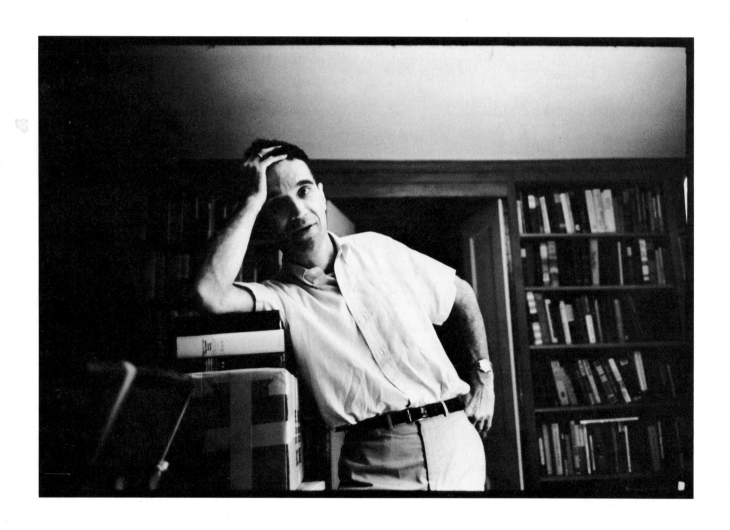

ROBERT COLES

Concord, Massachusetts, 1972

Opposite:
ROBERT PENN WARREN &
ELEANOR CLARK
Fairfield, Connecticut, 1977

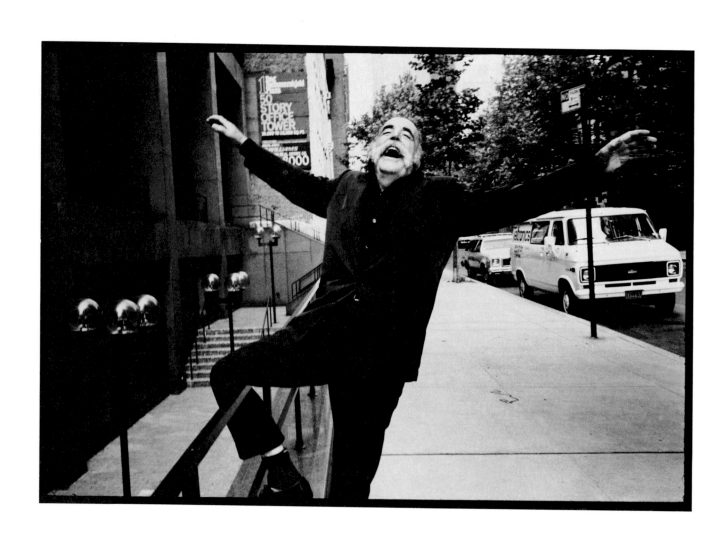

WILLIAM SAROYAN
New York City, 1975

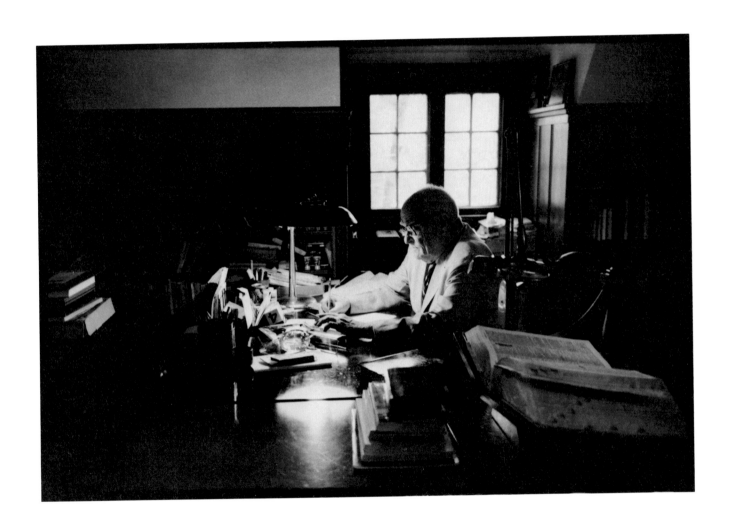

THORNTON WILDER

Hamden, Connecticut, 1973

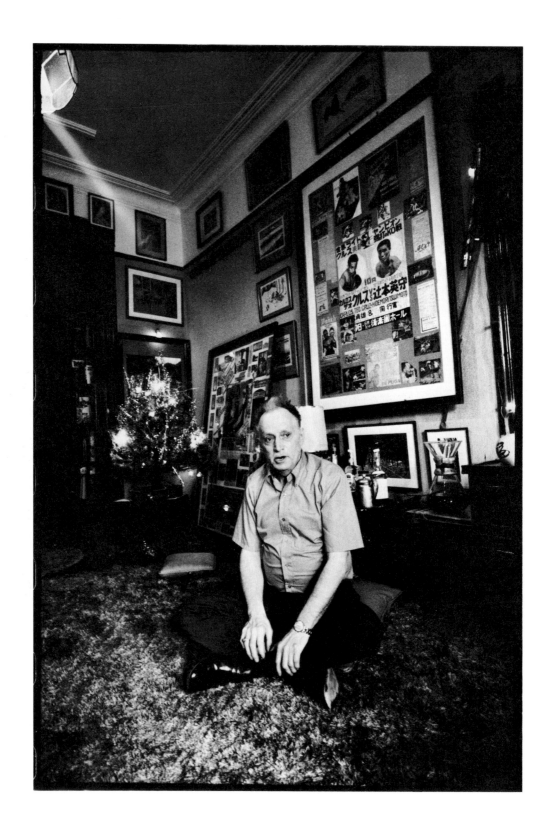

NELSON ALGREN

Chicago, Illinois, 1971

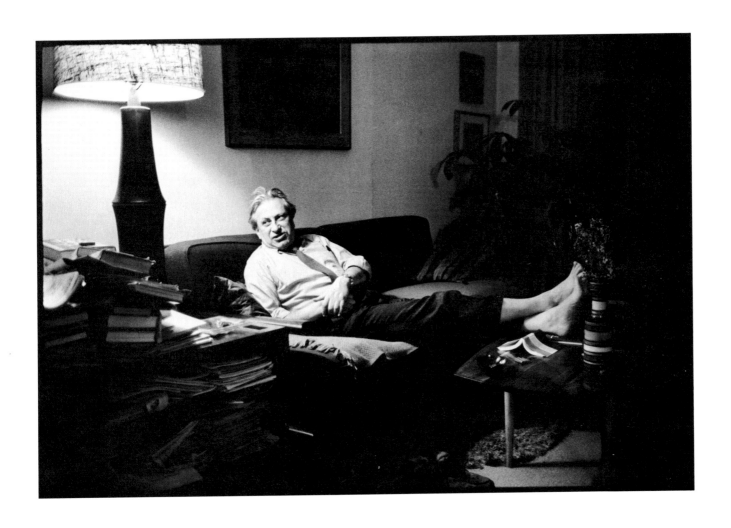

STUDS TERKEL

Chicago, Illinois, 1971

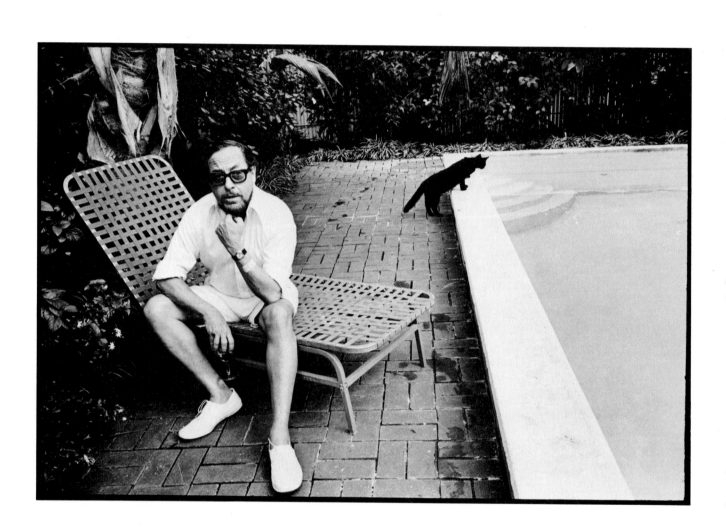

TENNESSEE WILLIAMS
Key West, Florida, 1972

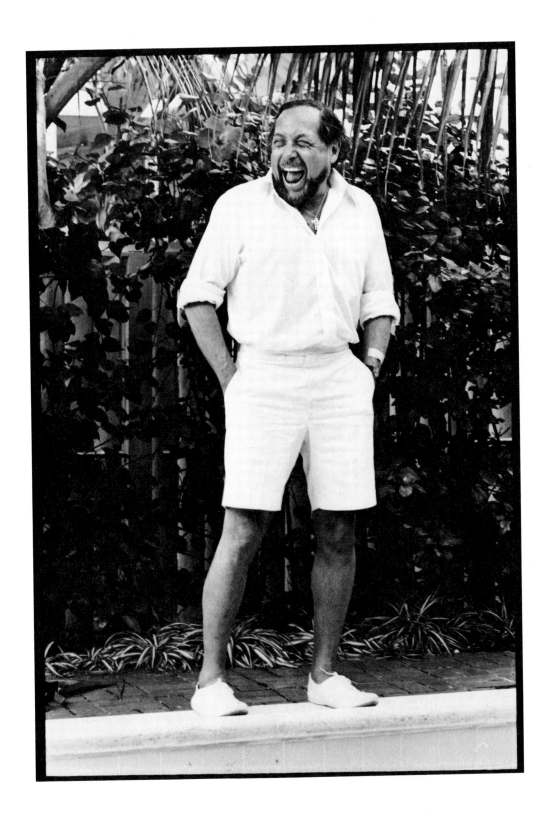

TENNESSEE WILLIAMS
Key West, Florida, 1972

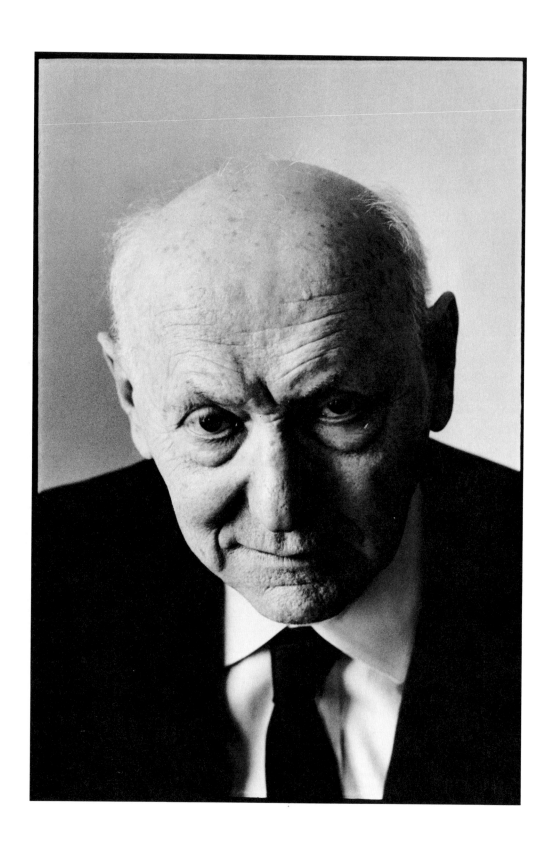

ISAAC BASHEVIS SINGER

New York City, 1972

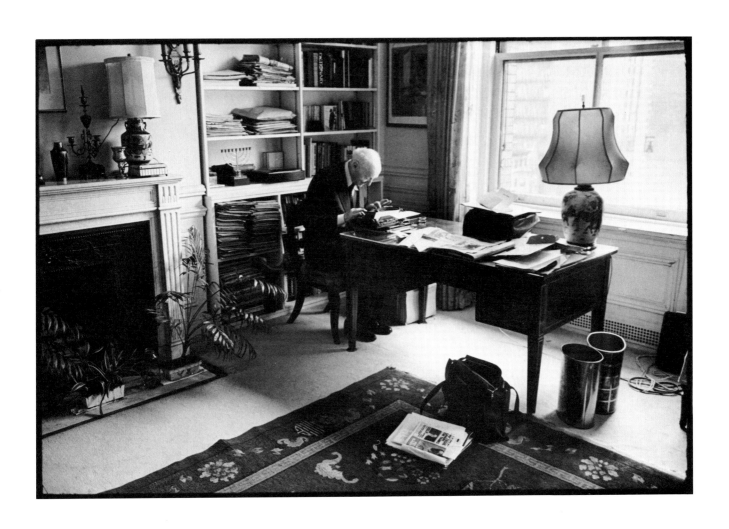

ISAAC BASHEVIS SINGER

New York City, 1978

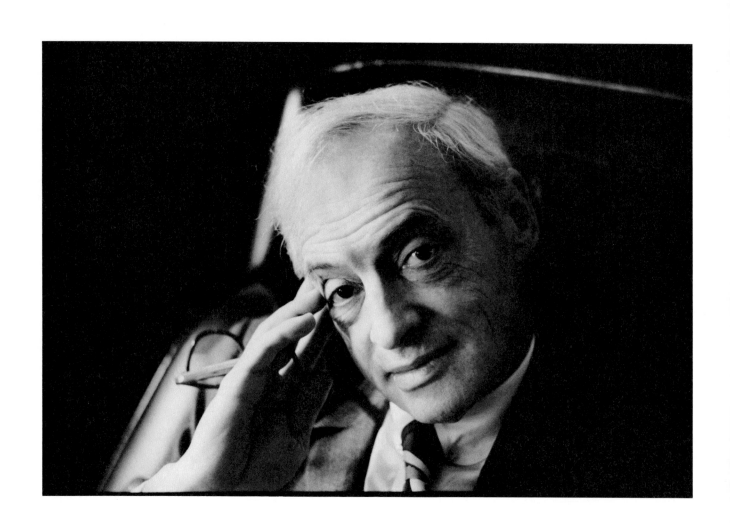

SAUL BELLOW
Chicago, Illinois, 1971

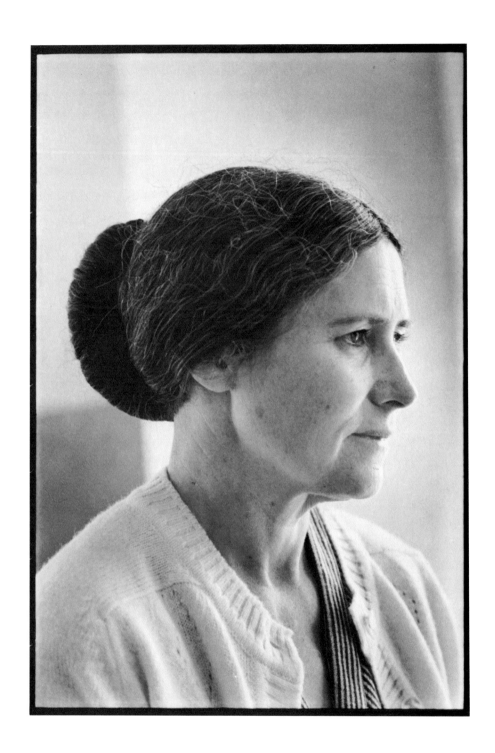

DORIS LESSING
New York City, 1972

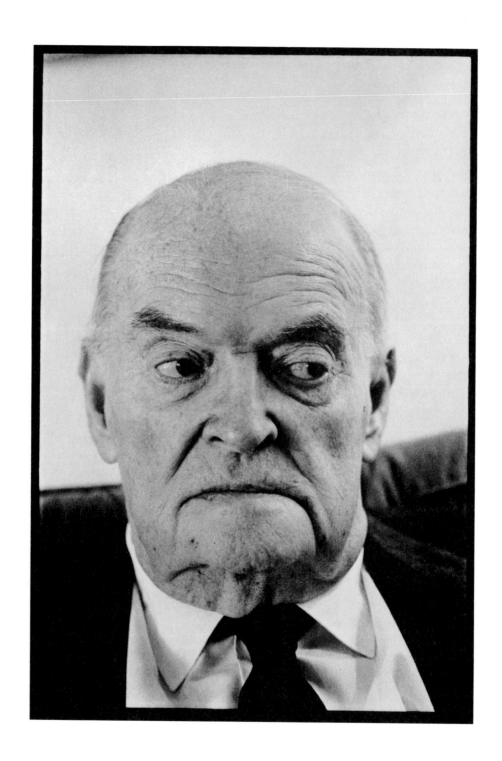

EDMUND WILSON

Naples, Florida, 1972

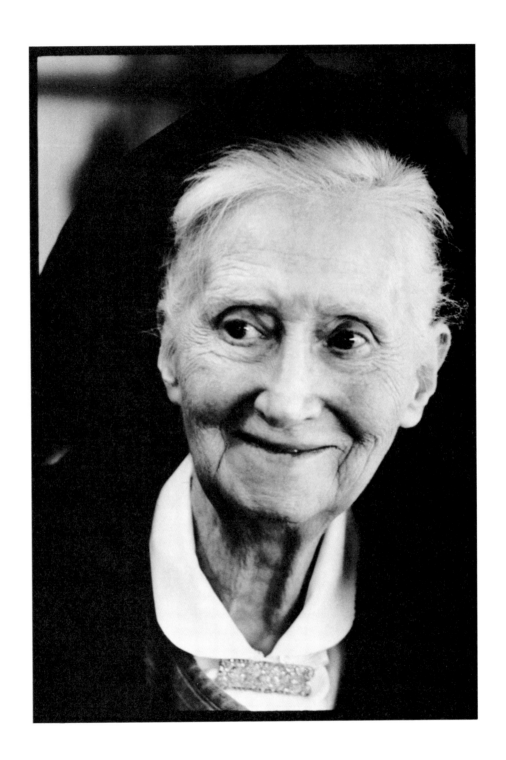

MARIANNE MOORE
New York City, 1968

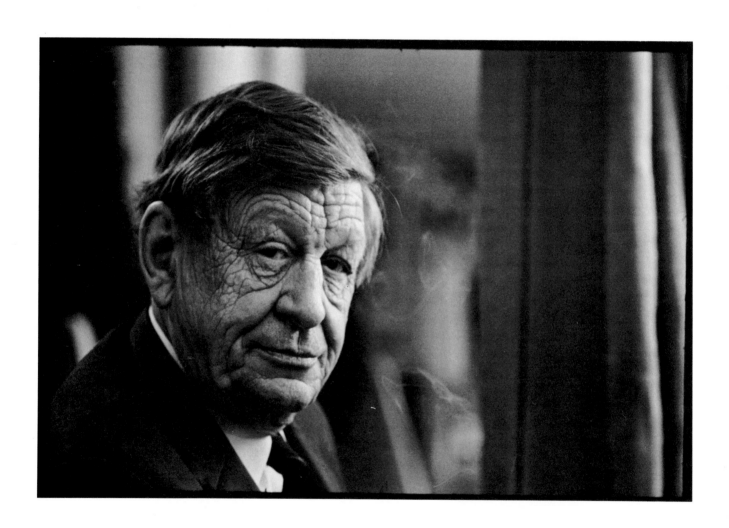

W. H. AUDEN

New York City, 1967

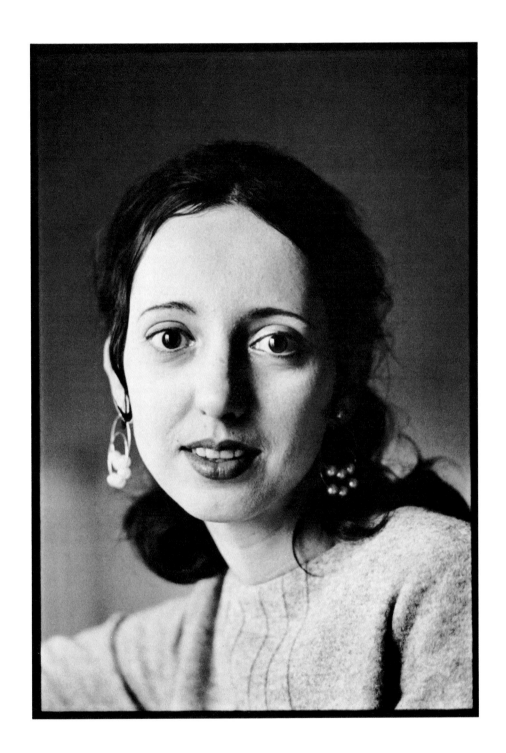

JOYCE CAROL OATES

London, 1971

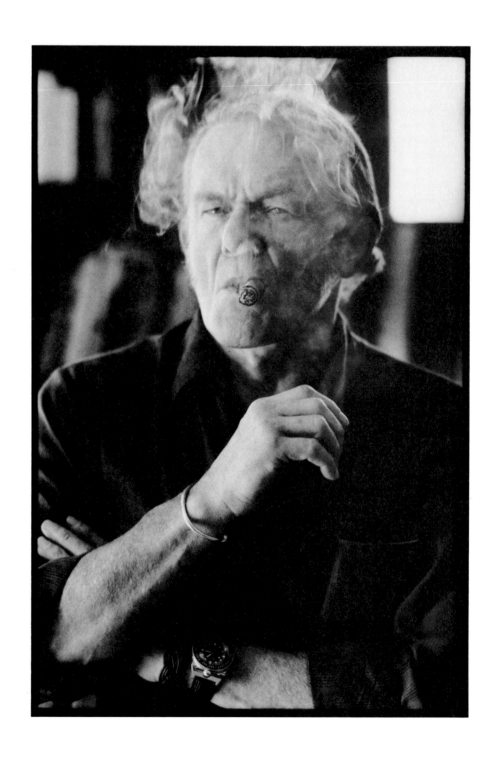

JAMES JONES
Paris, 1972

Opposite:
JOSEPH HELLER
with a copy of *Catch 22*
New York City, 1974

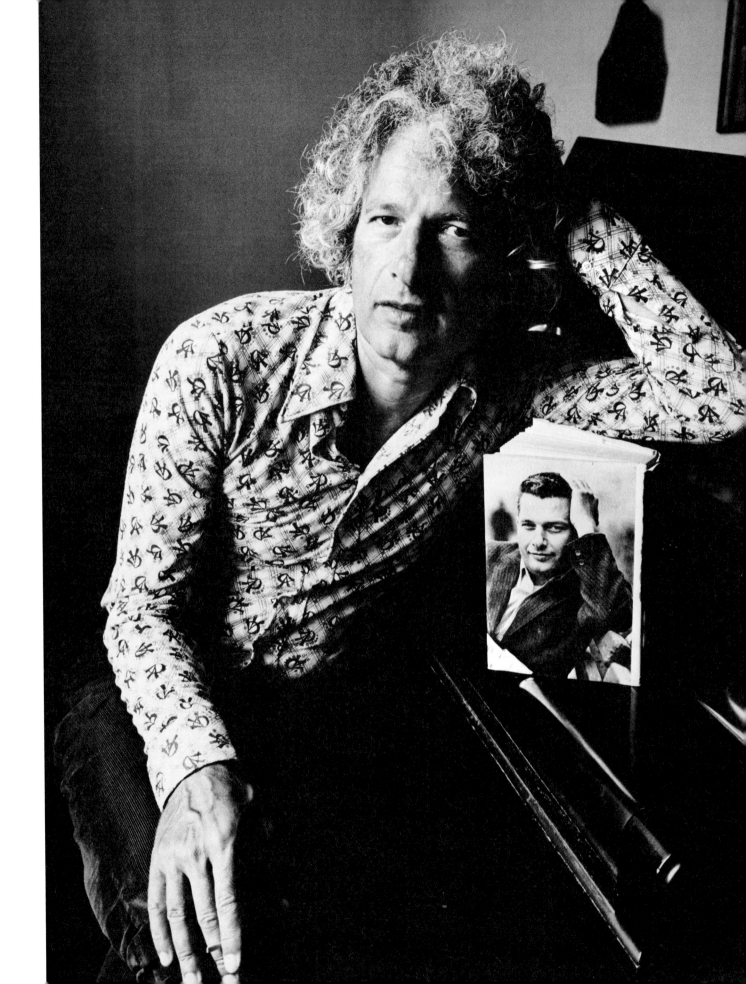

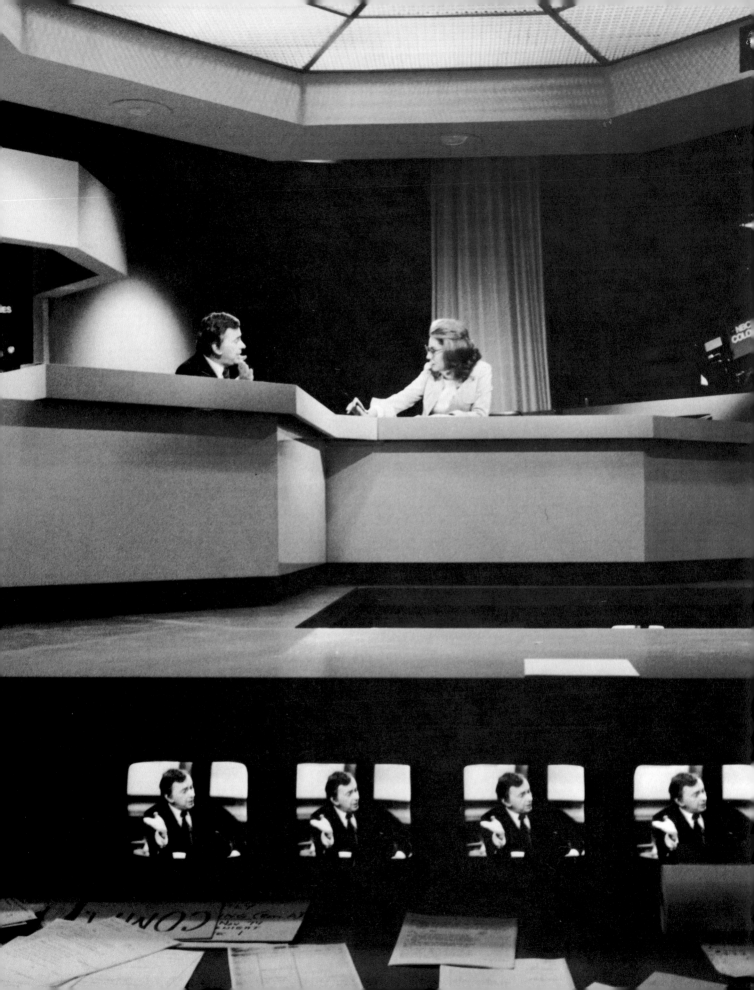

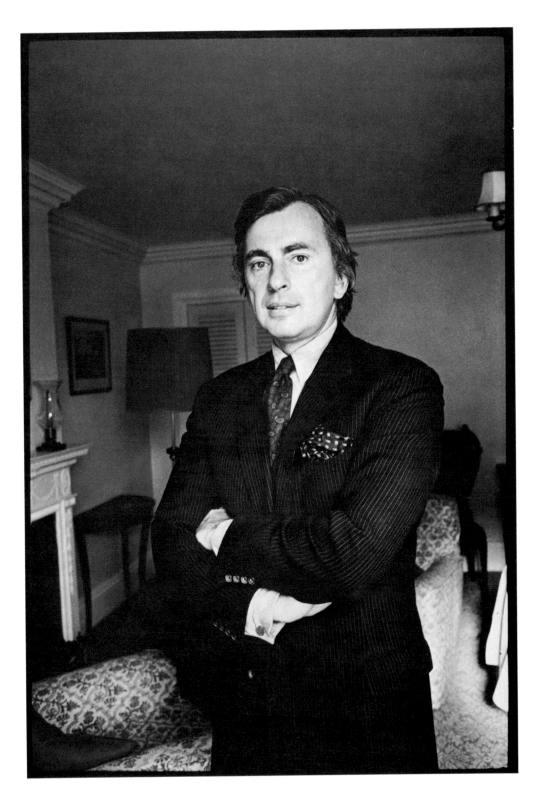

Opposite:
GORE VIDAL
on the *Today* show with Barbara Walters
New York City, 1974

GORE VIDAL
London, 1972

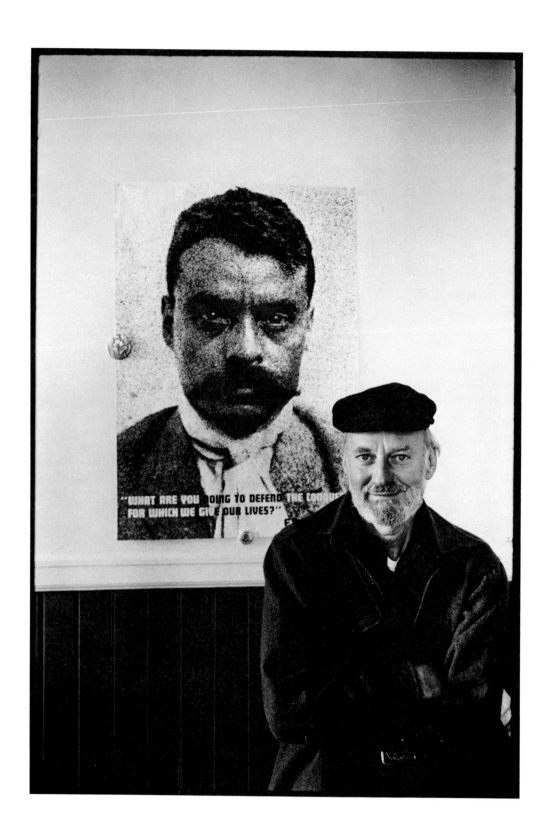

LAWRENCE FERLINGHETTI

San Francisco, California, 1975

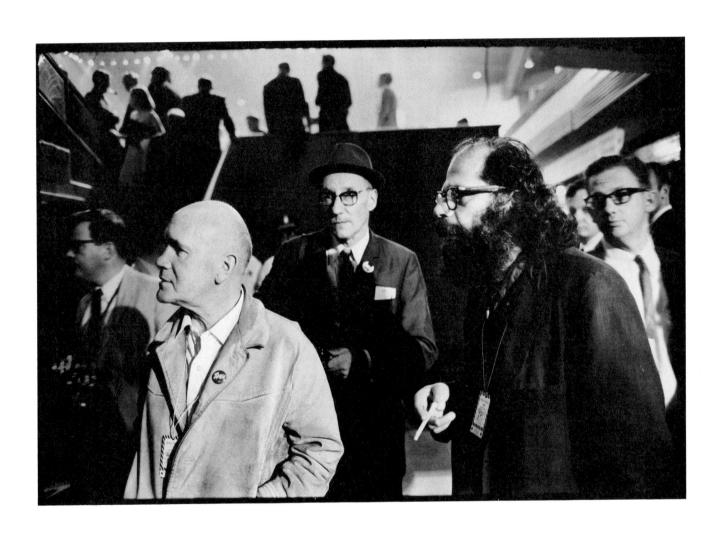

JEAN GENET, WILLIAM BURROUGHS & ALLEN GINSBERG
Democratic Convention, Chicago, Illinois, 1968

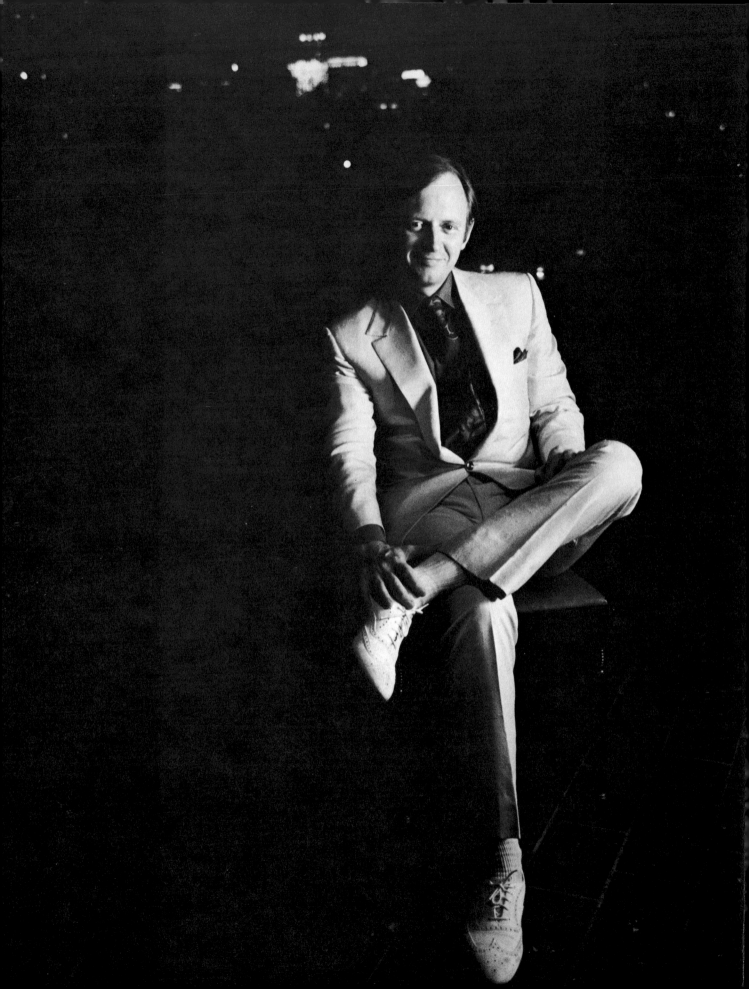

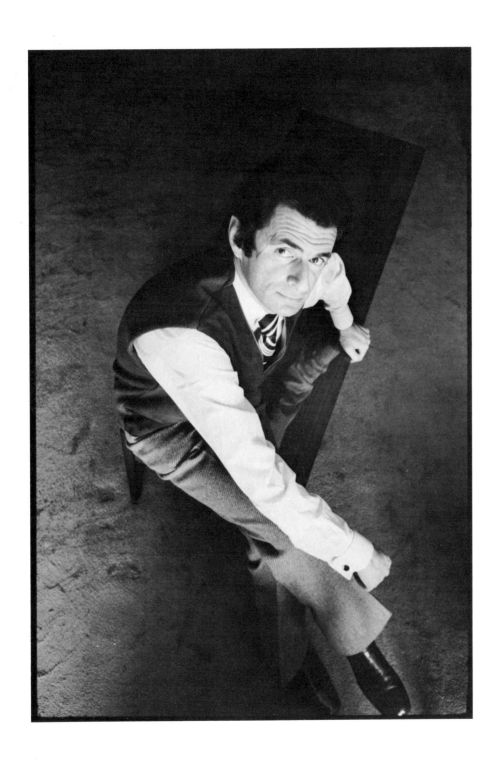

Opposite:
TOM WOLFE
New York City, 1973

JERZY KOSINSKI
New York City, 1971

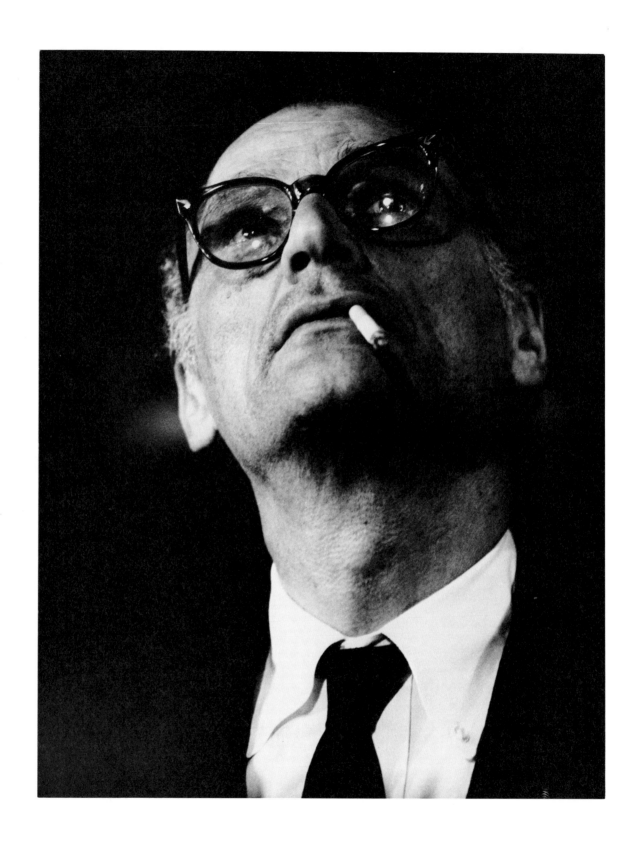

ARTHUR MILLER
New York City, 1969

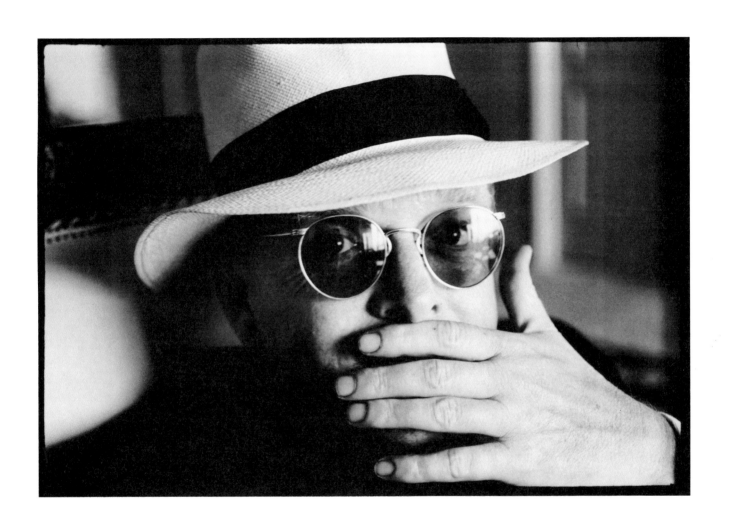

TRUMAN CAPOTE
New York City, 1969

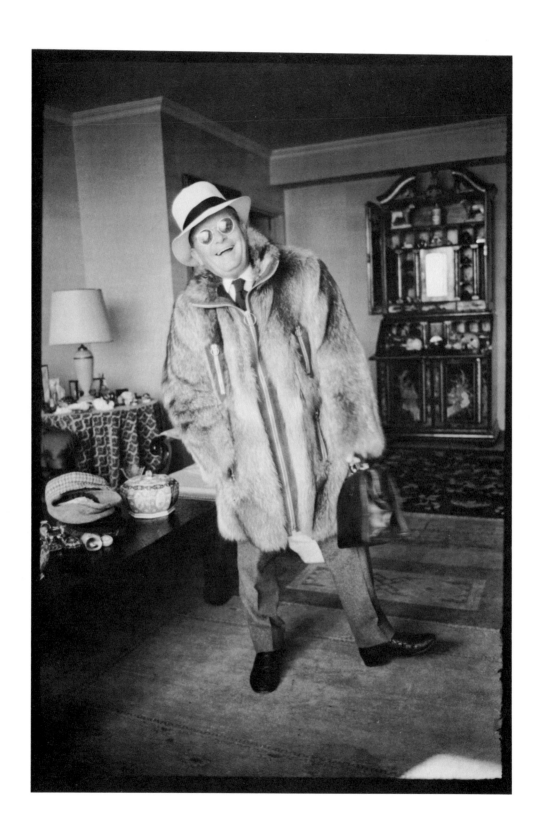

TRUMAN CAPOTE
New York City, 1969

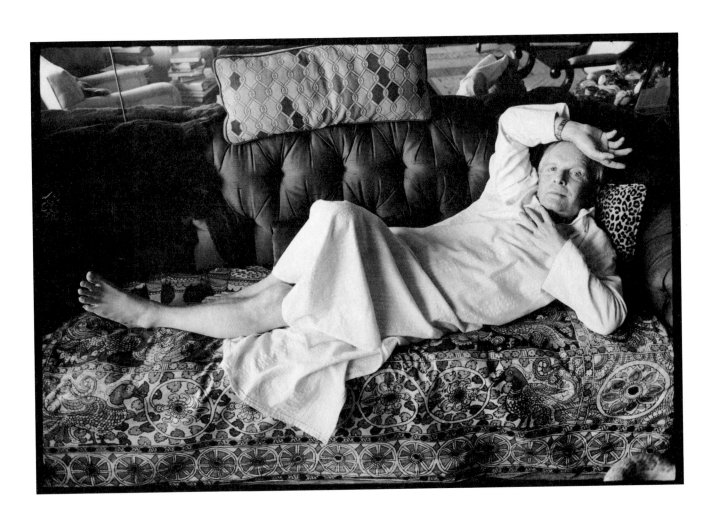

TRUMAN CAPOTE
New York City, 1980

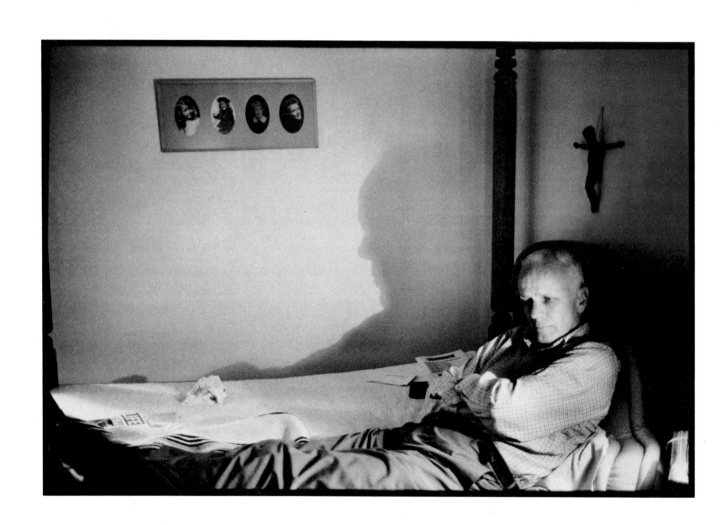

WALKER PERCY

Covington, Louisiana, 1972

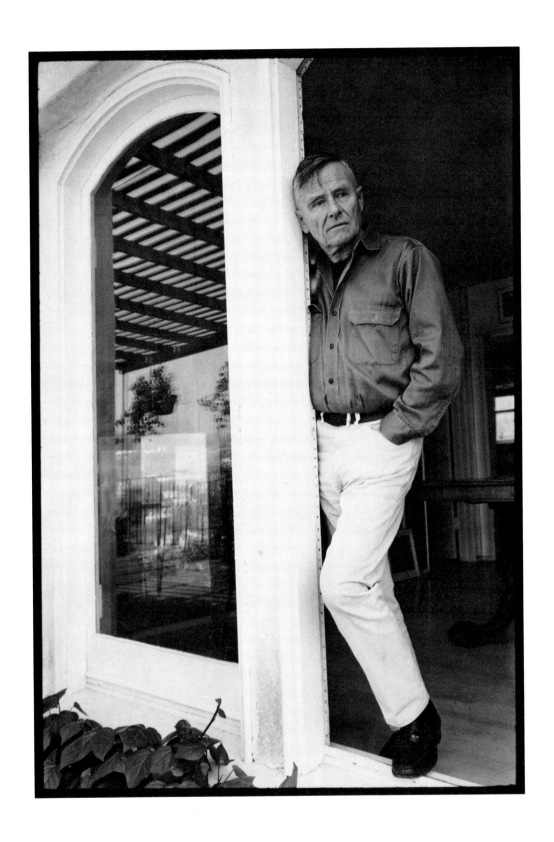

CHRISTOPHER ISHERWOOD
Santa Monica, California, 1972

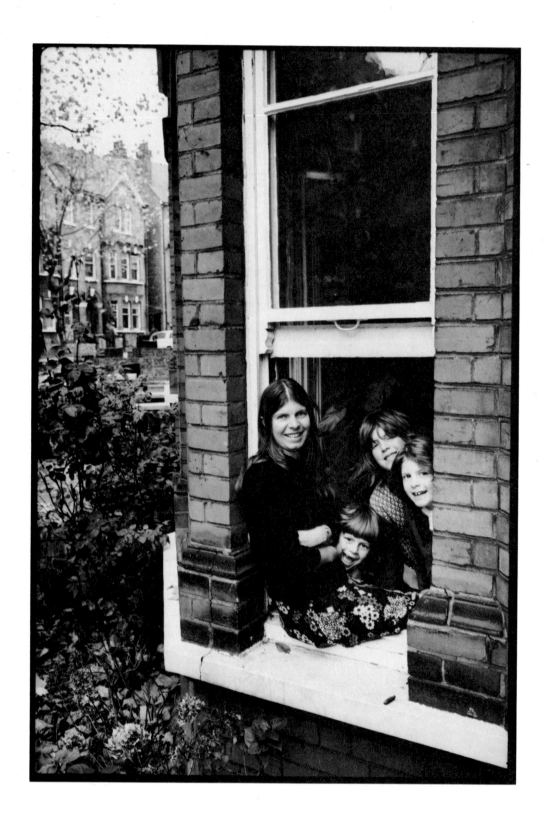

MARGARET DRABBLE
with her children, Adam, Rebecca, and Joseph
London, 1972

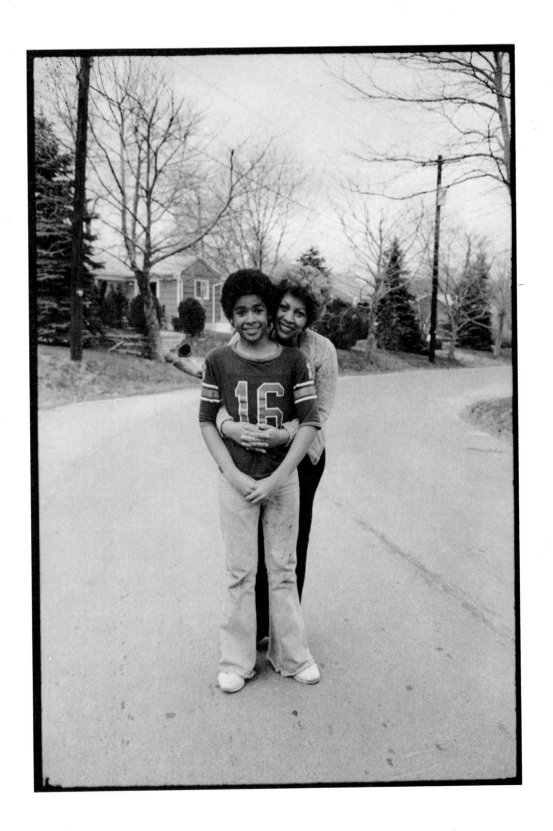

TONI MORRISON
with her son, Slade
Spring Valley, New York, 1978

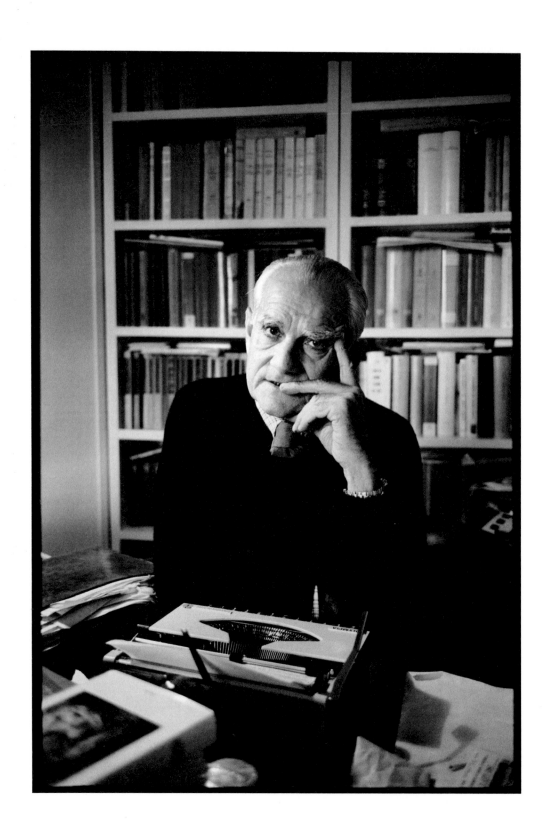

ALBERTO MORAVIA

Rome, 1974

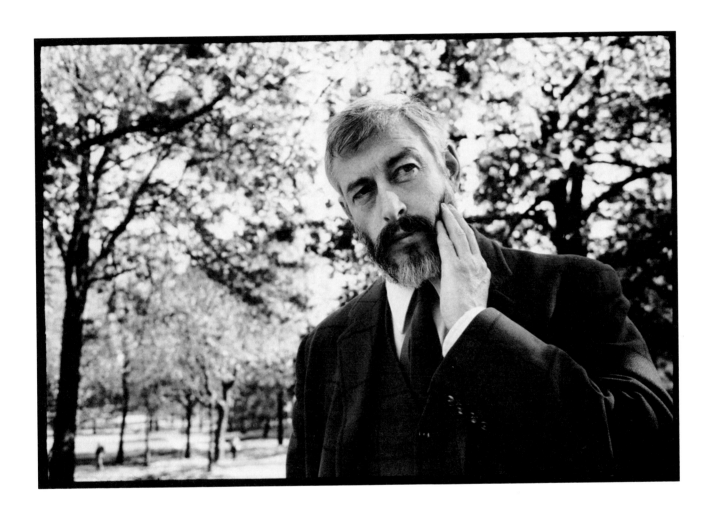

J. P. DONLEAVY
New York City, 1973

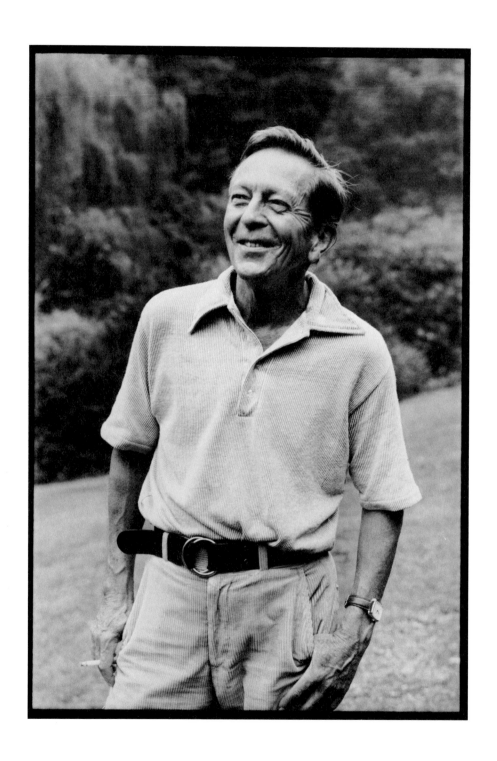

JOHN CHEEVER

Ossining, New York, 1976

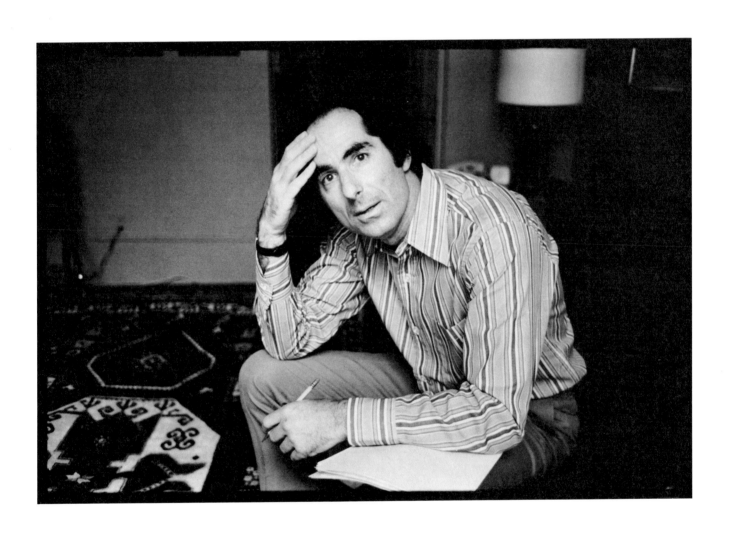

PHILIP ROTH
New York City, 1972

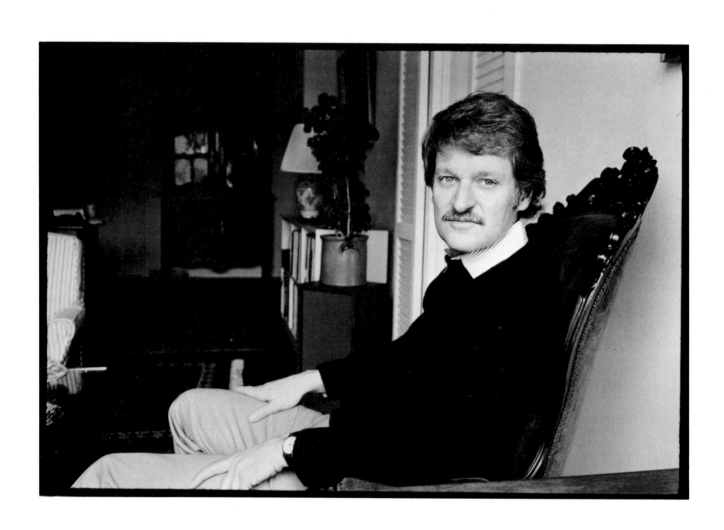

JOHN ASHBERY
New York City, 1975

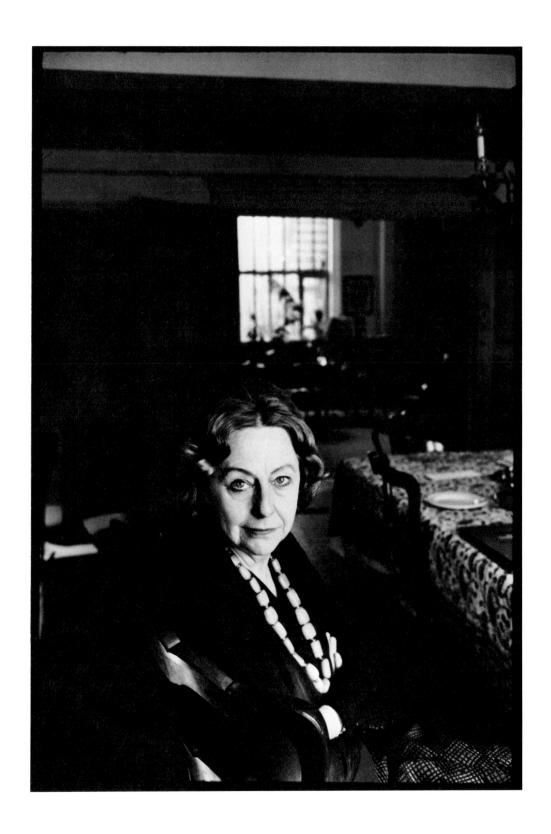

ELIZABETH HARDWICK
New York City, 1974

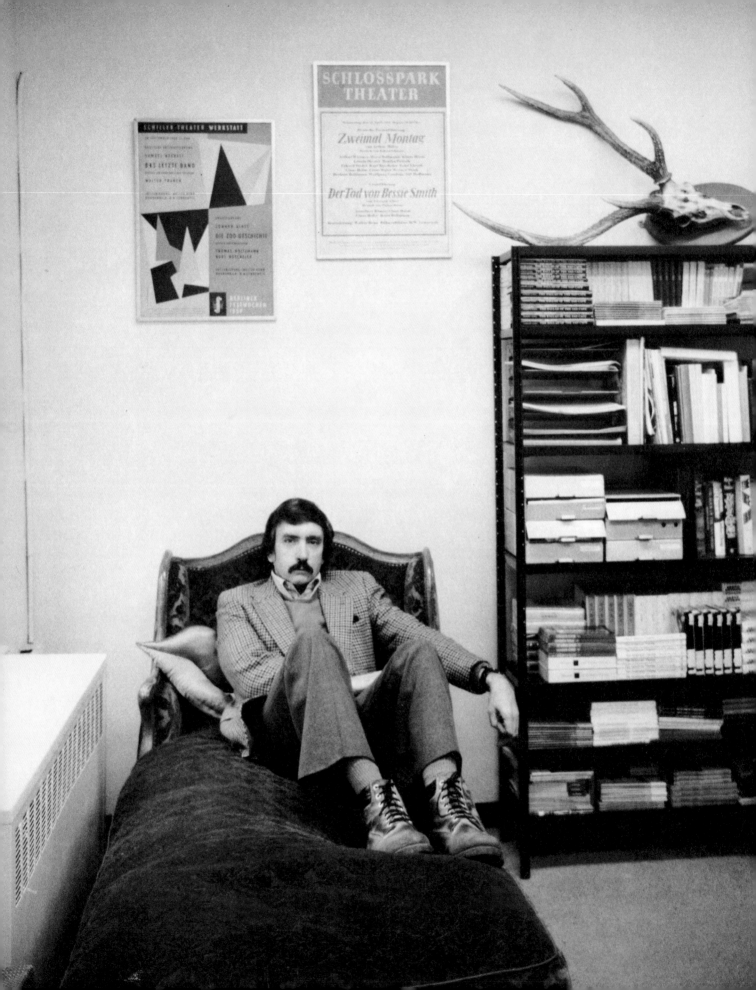

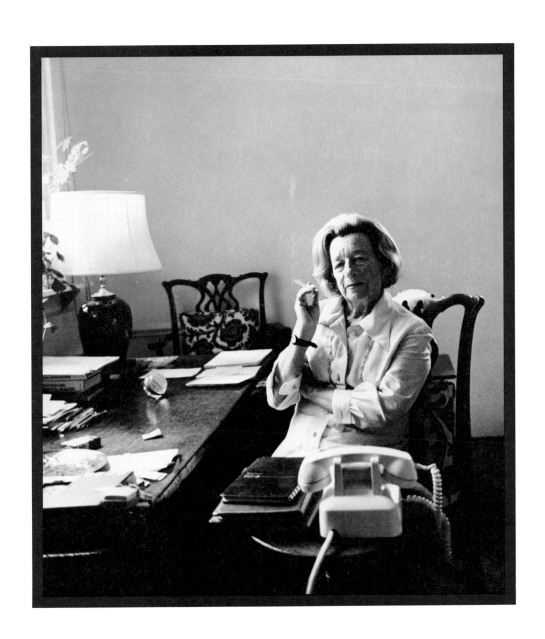

Opposite:
EDWARD ALBEE
New York City, 1975

LILLIAN HELLMAN
New York City, 1974

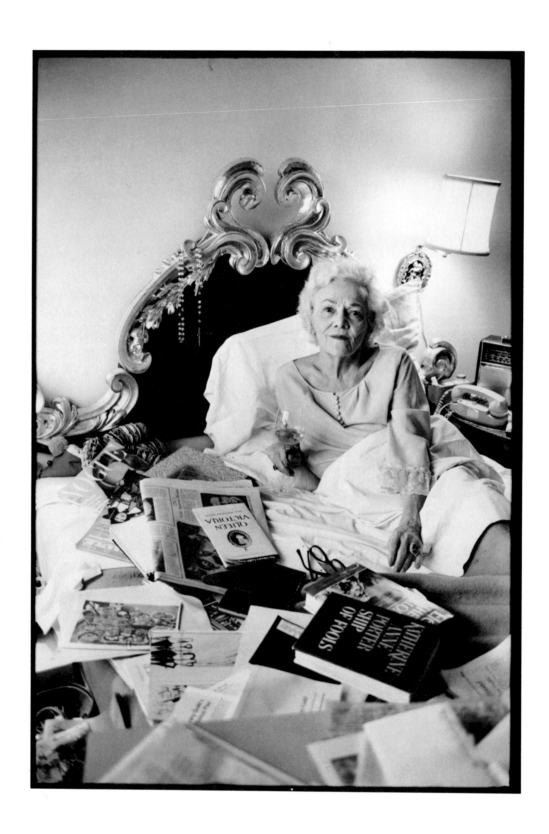

KATHERINE ANNE PORTER
College Park, Maryland, 1972

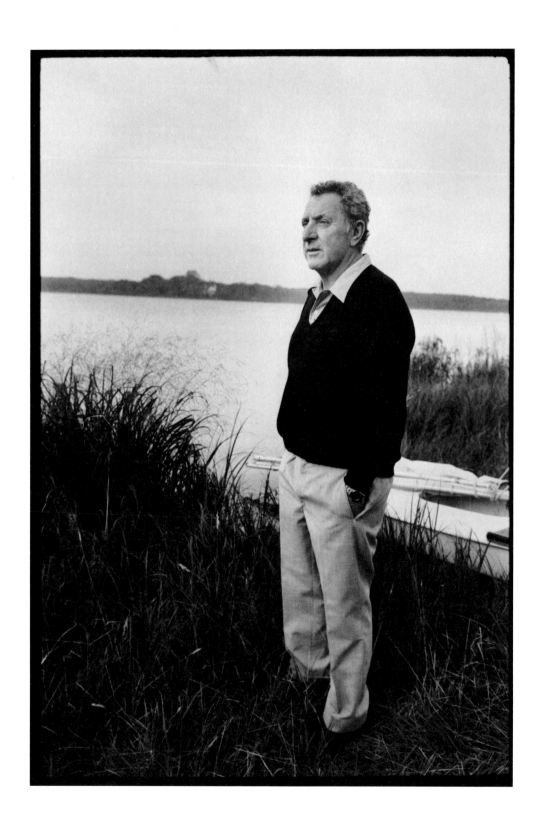

IRWIN SHAW

Wainscott, Long Island, 1976

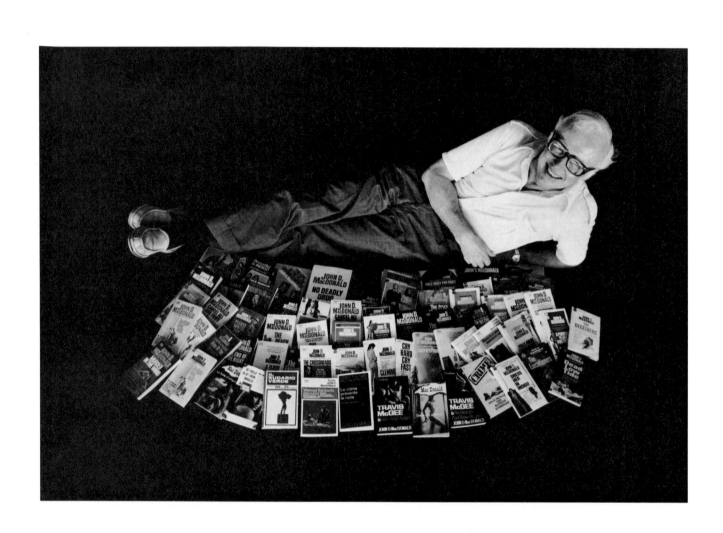

JOHN D. MACDONALD

Sarasota, Florida, 1973

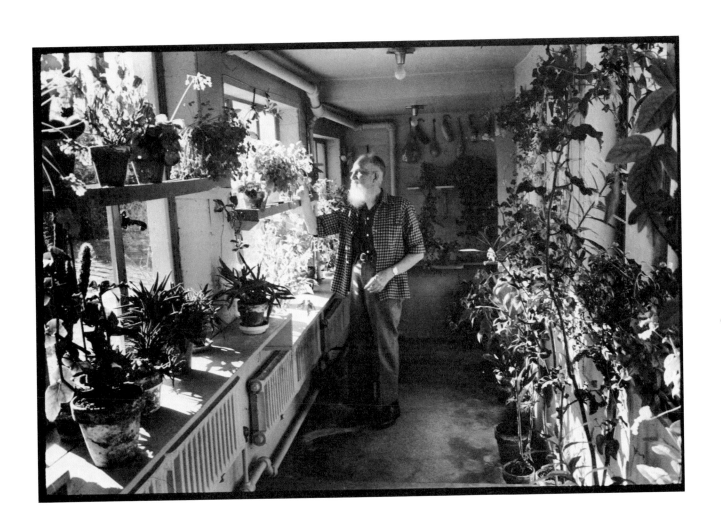

REX STOUT
Brewster, New York, 1973

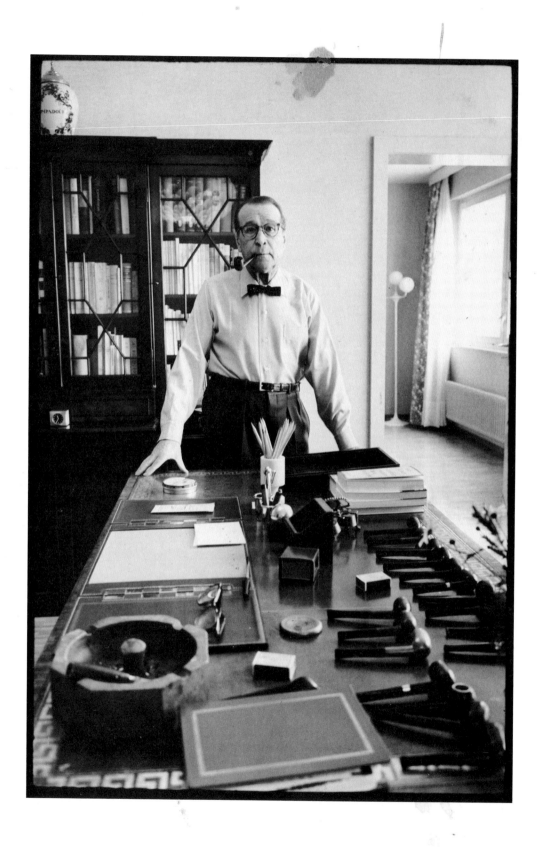

GEORGES SIMENON

Lausanne, Switzerland, 1973

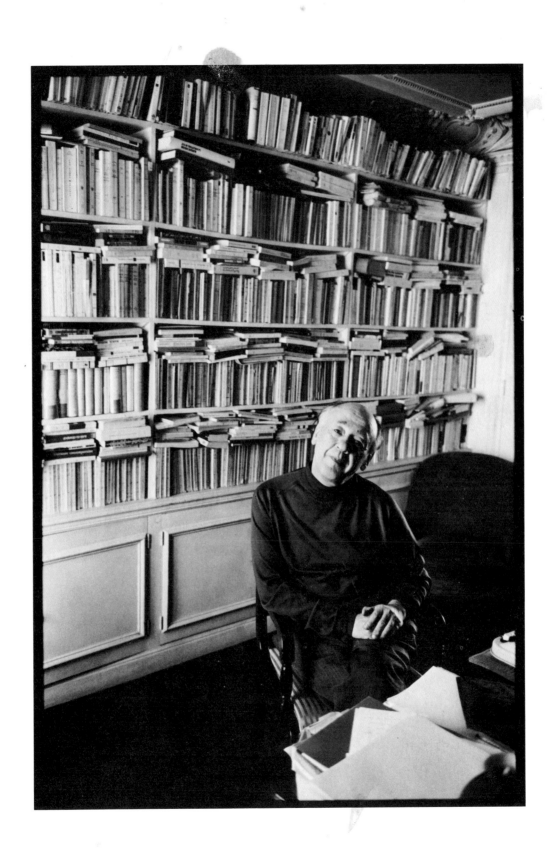

EUGENE IONESCO

Paris, 1973

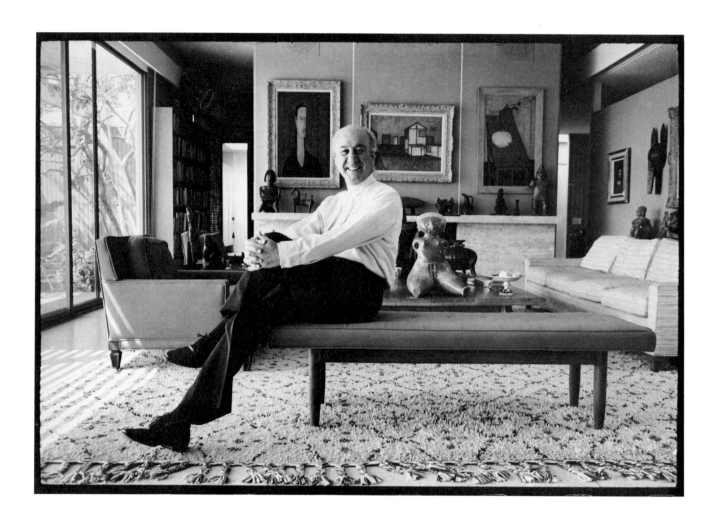

IRVING STONE
Beverly Hills, California, 1972

Opposite:
HERMAN WOUK
Washington, D.C., 1973

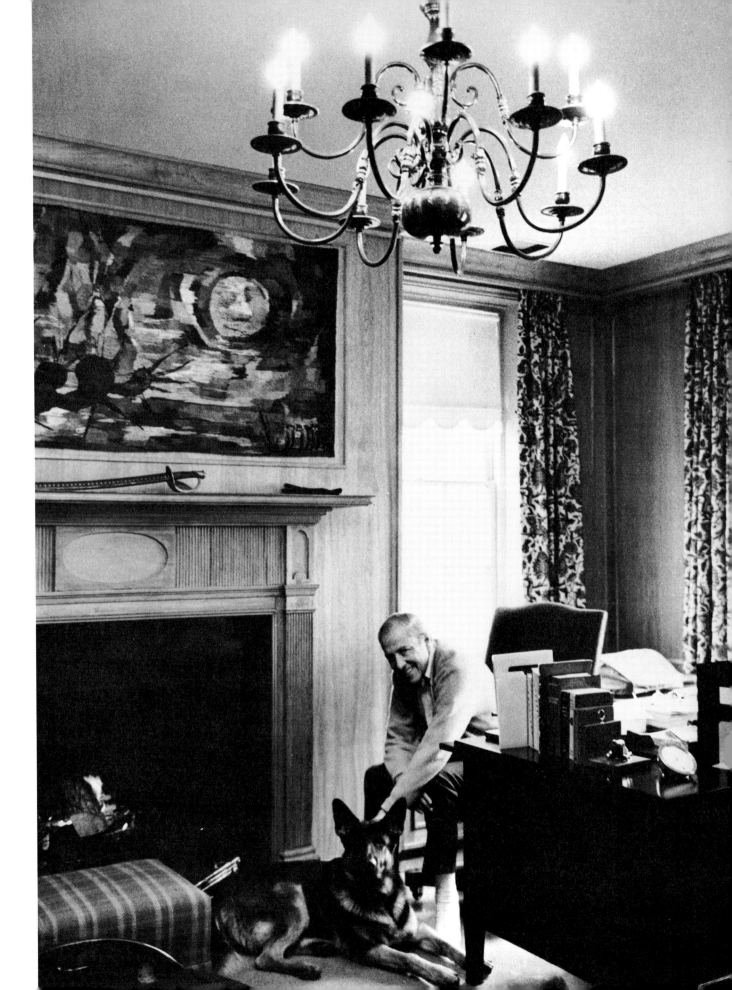

PAUL THEROUX
Taunton Railway Station, England, 1973

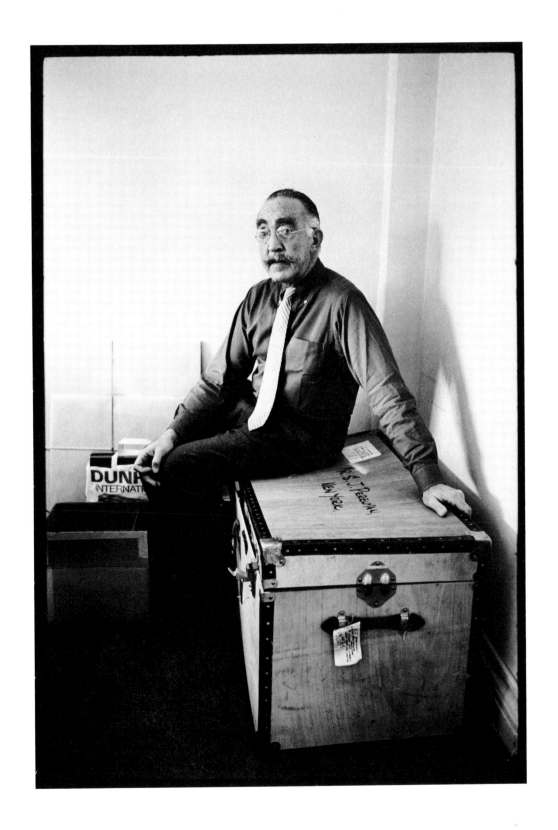

S. J. PERELMAN
New York City, 1973

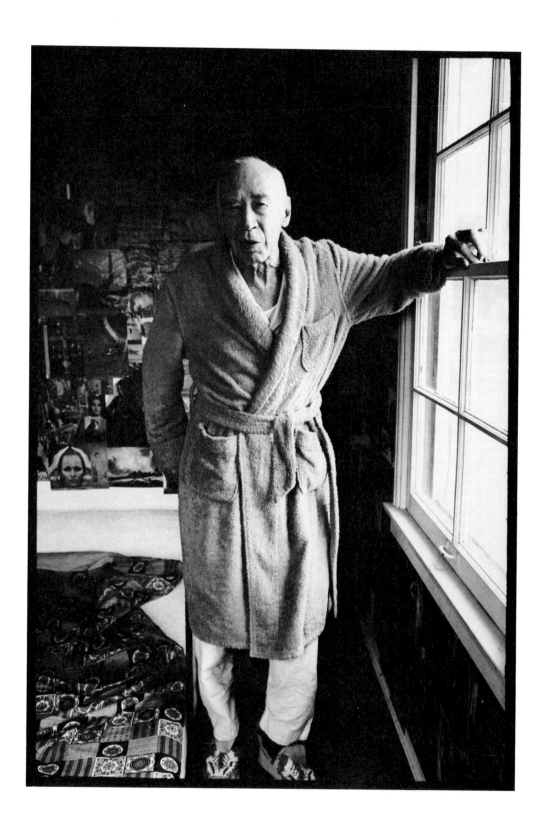

HENRY MILLER
Pacific Palisades, California, 1974

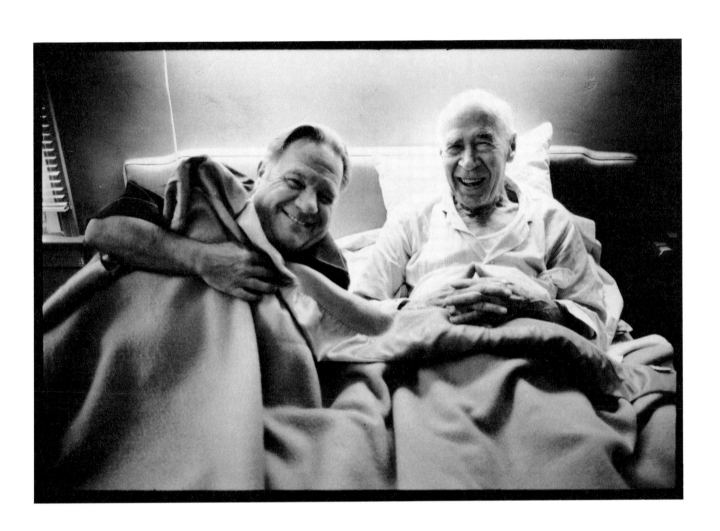

HENRY MILLER & LAWRENCE DURRELL

Pacific Palisades, California, 1974

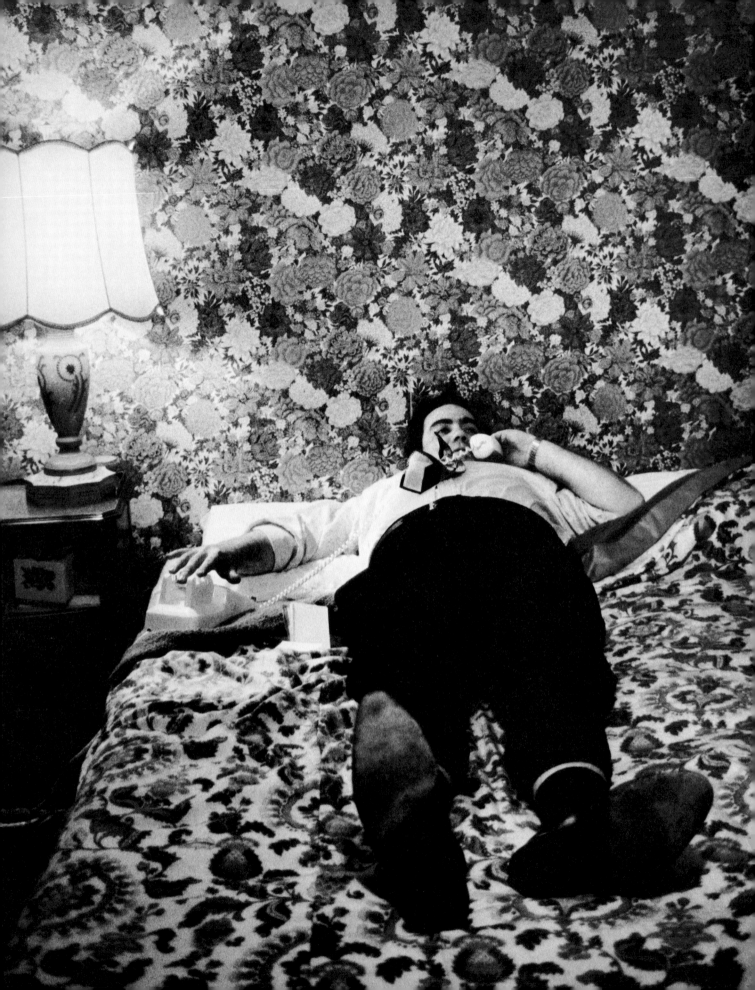

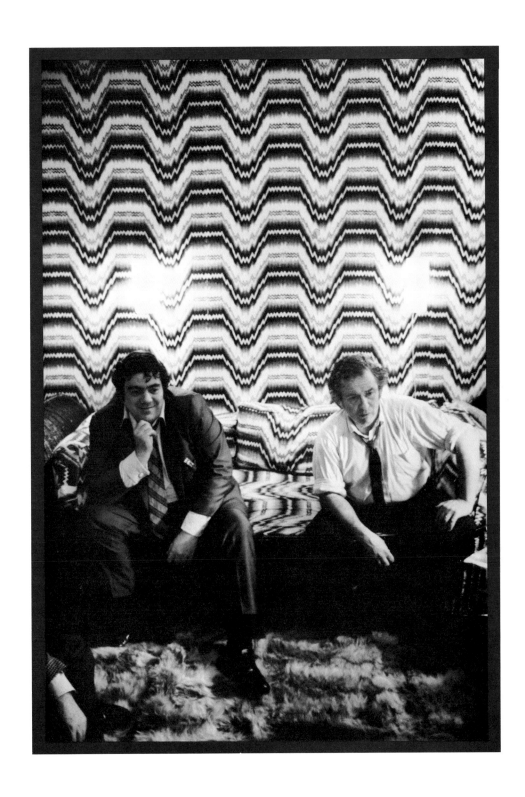

Opposite:
JIMMY BRESLIN
Forest Hills, New York, 1968

JIMMY BRESLIN & NORMAN MAILER
during the mayoral campaign
New York City, 1969

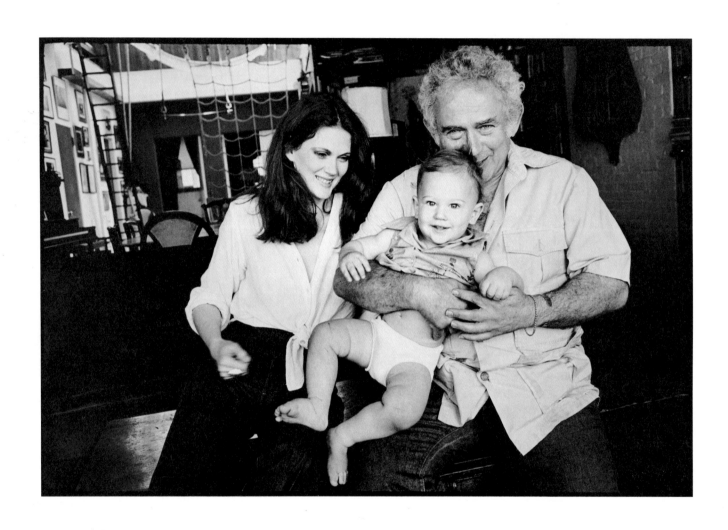

NORMAN MAILER & NORRIS CHURCH
with their son, John Buffalo
Brooklyn Heights, New York, 1980

Opposite:
NORMAN MAILER
New York City, 1971

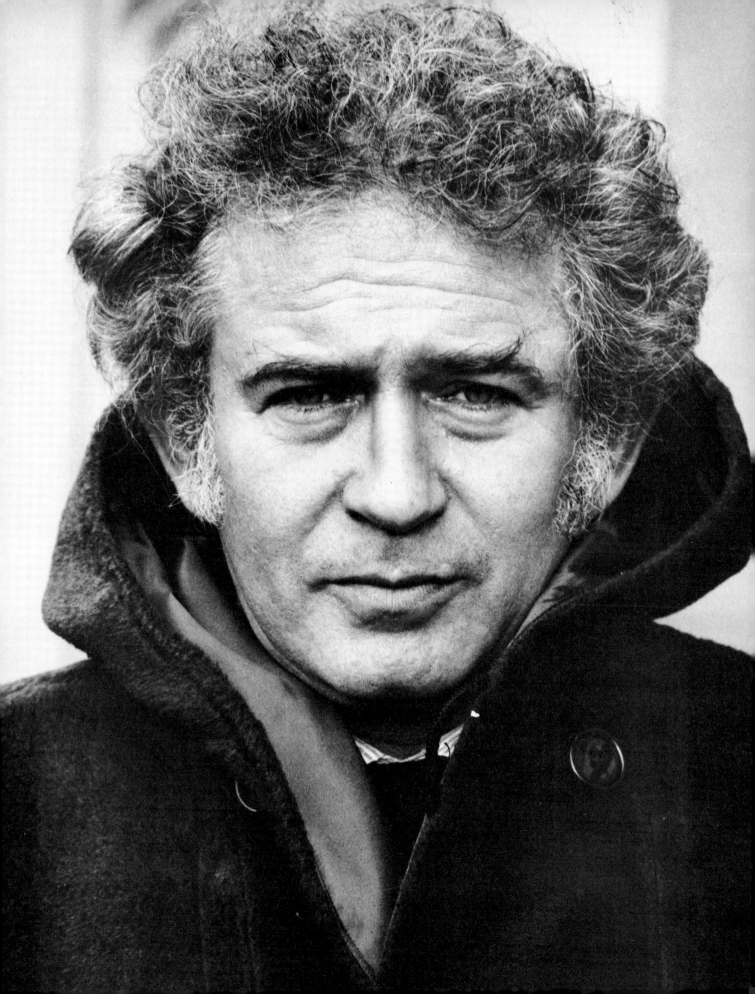

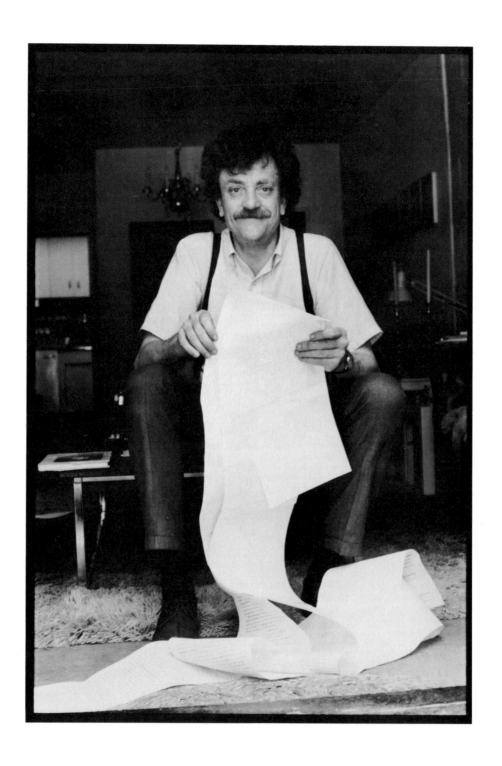

KURT VONNEGUT
with manuscript of *Breakfast of Champions*
New York City, 1972

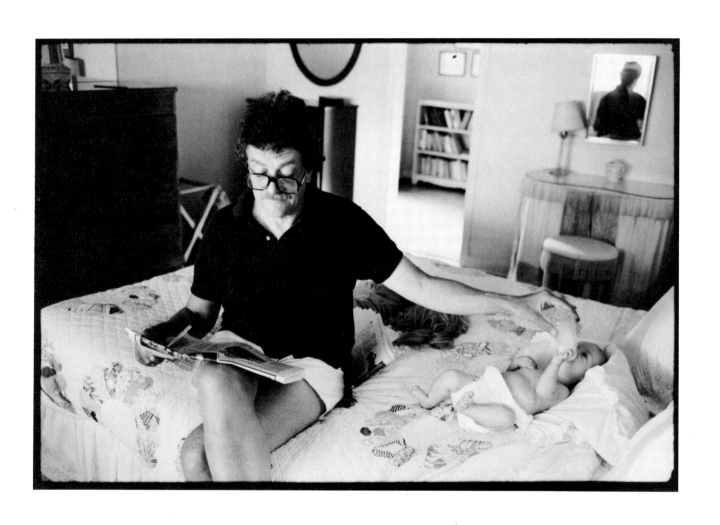

KURT VONNEGUT
with his grandson, Zachary
East Hampton, Long Island, 1977

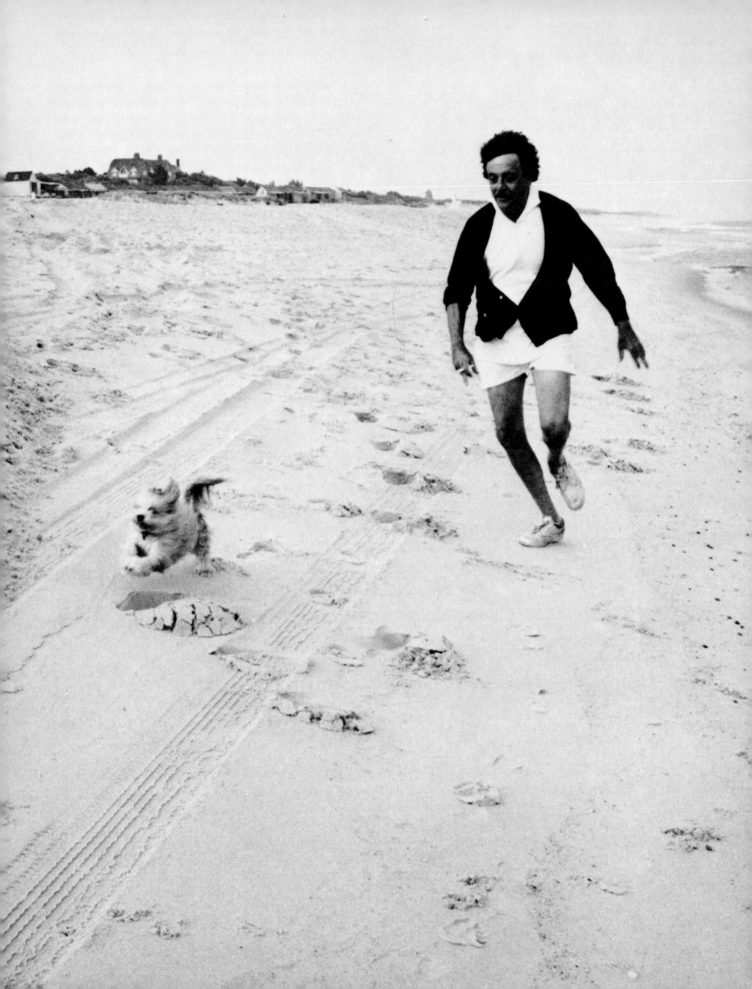

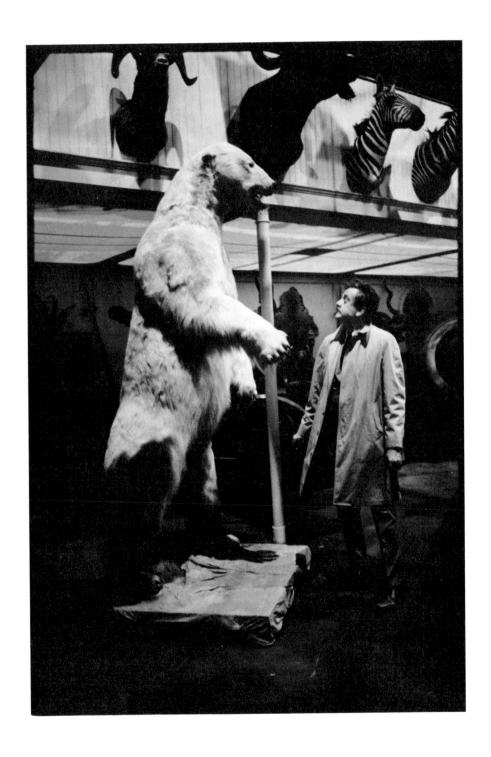

Opposite:
KURT VONNEGUT
East Hampton, Long Island, 1973

KURT VONNEGUT
on the movie set of *Happy Birthday, Wanda June*
Hollywood, California, 1971

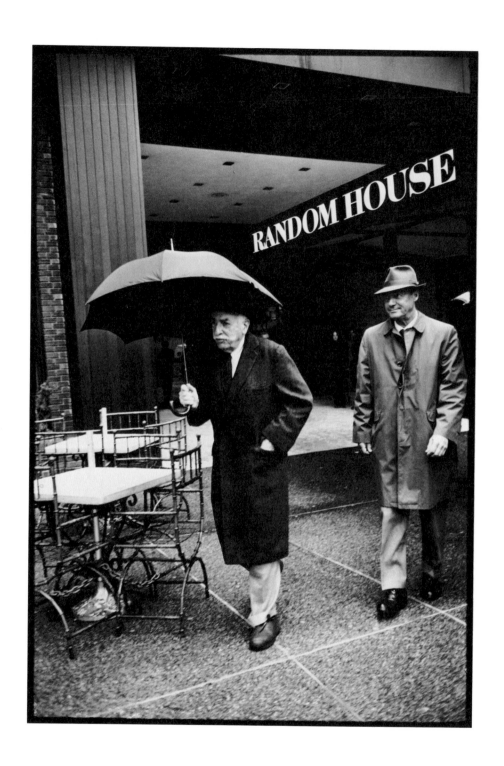

ALFRED A. KNOPF & ROSS MACDONALD
New York City, 1974

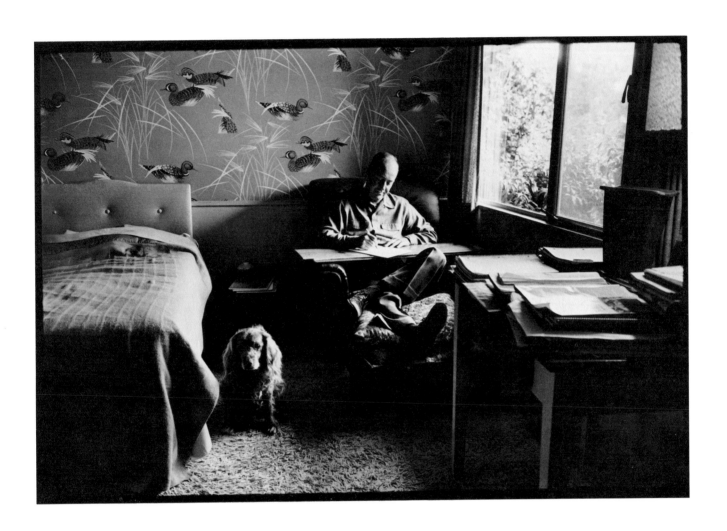

ROSS MACDONALD

Santa Barbara, California, 1974

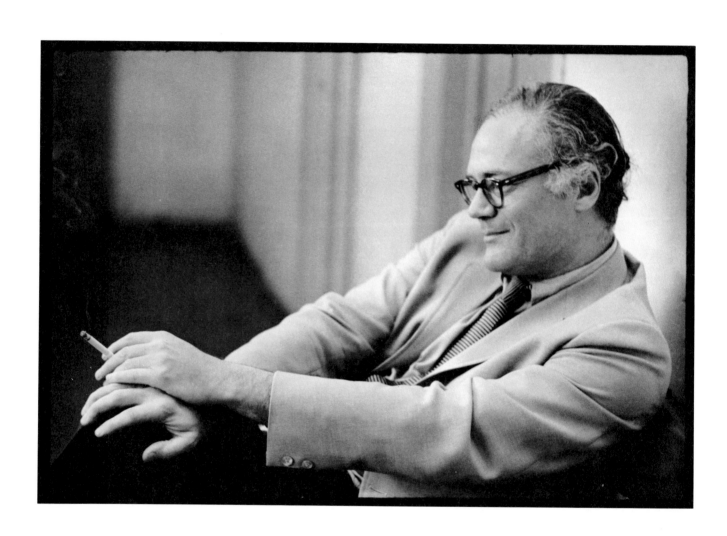

ROBERT LOWELL
New York City, 1968

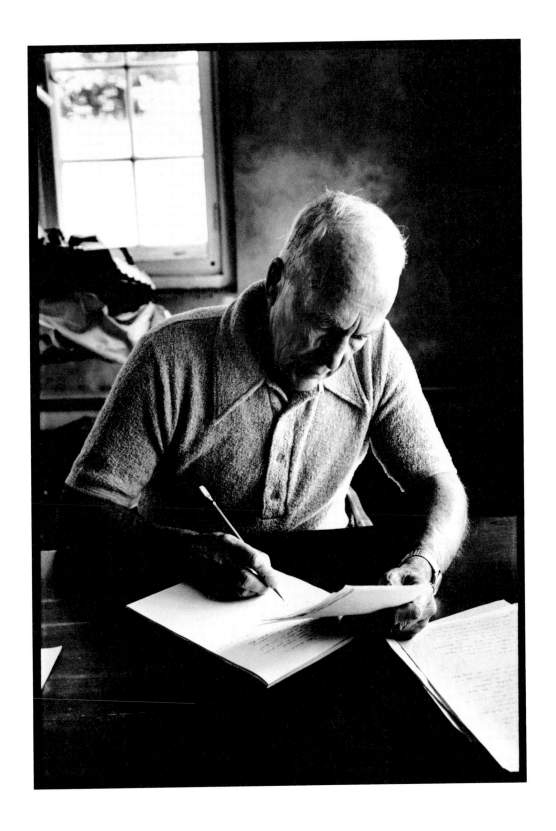

ARCHIBALD MACLEISH
Conway, Massachusetts, 1972

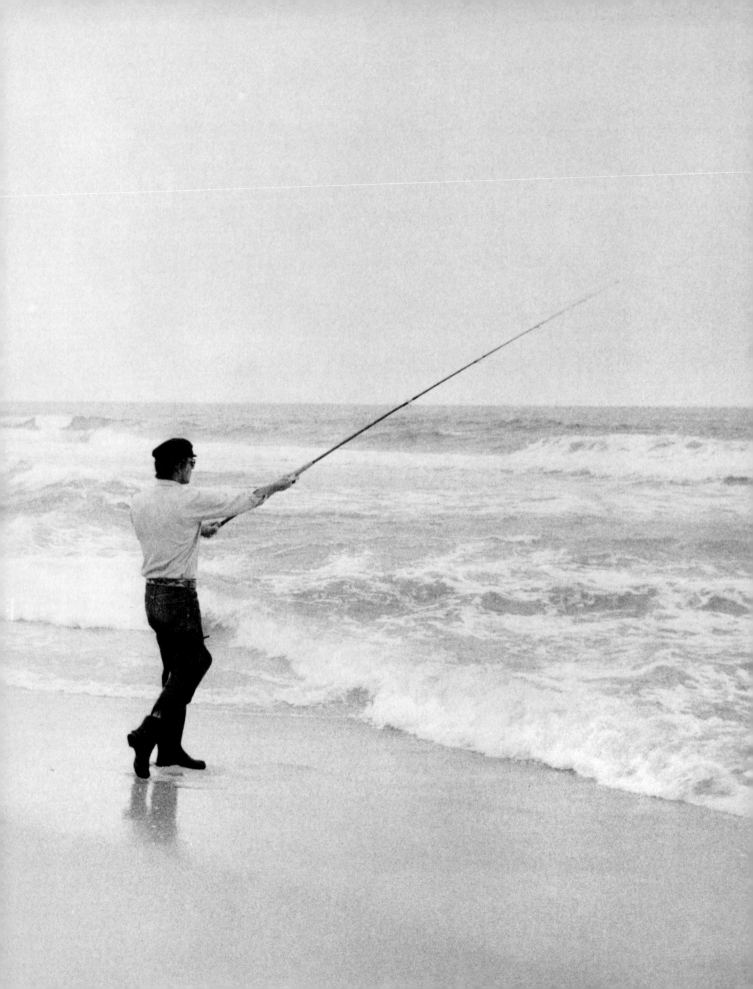

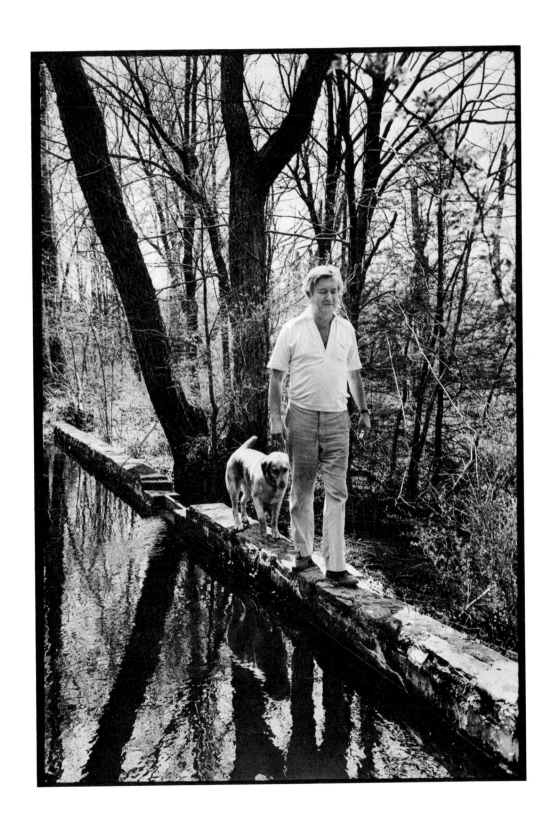

Opposite:
PETER MATTHIESSEN
Sagaponack, Long Island, 1975

WILLIAM STYRON
Roxbury, Connecticut, 1979

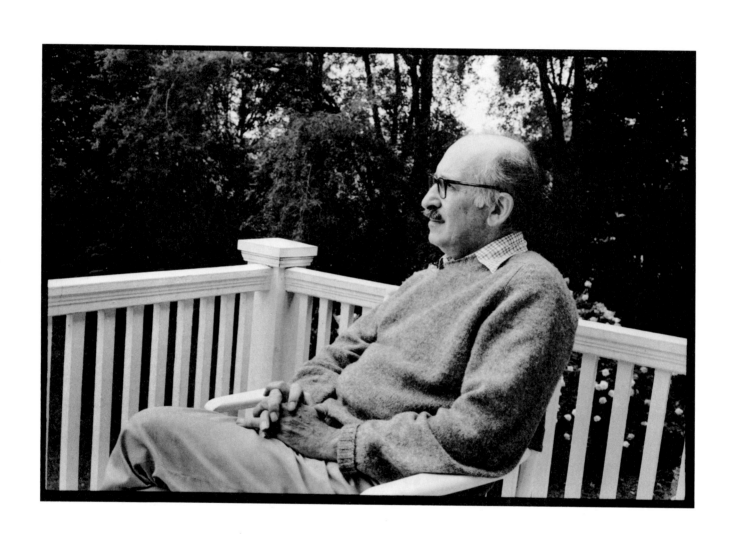

BERNARD MALAMUD
Old Bennington, Vermont, 1971

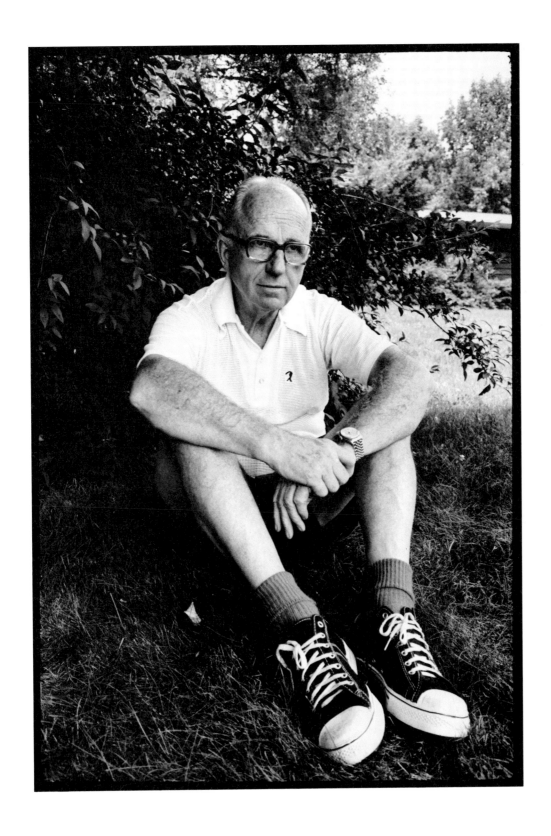

JAMES MICHENER
Bucks County, Pennsylvania, 1974

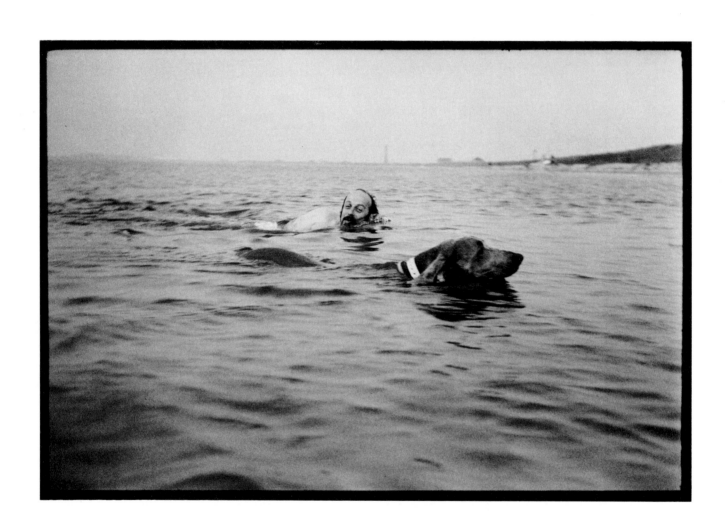

E. L. DOCTOROW

Amagansett, Long Island, 1975

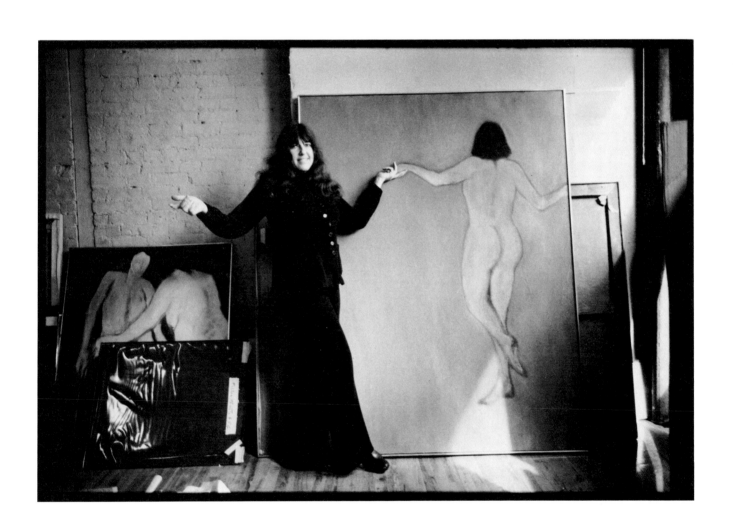

ROSALYN DREXLER
New York City, 1975

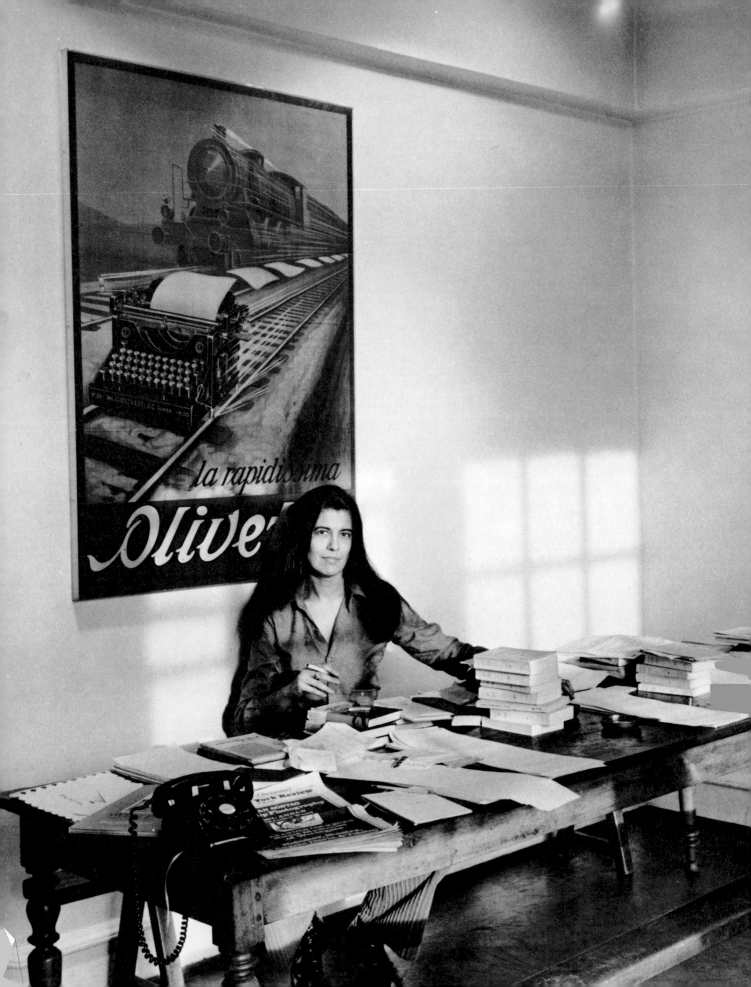

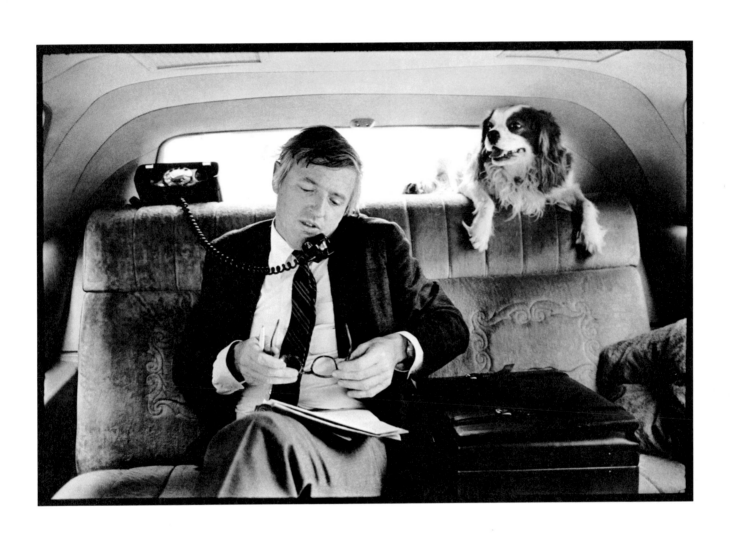

Opposite:
SUSAN SONTAG
Sagaponack, Long Island, 1975

WILLIAM F. BUCKLEY, JR.
New York City, 1974

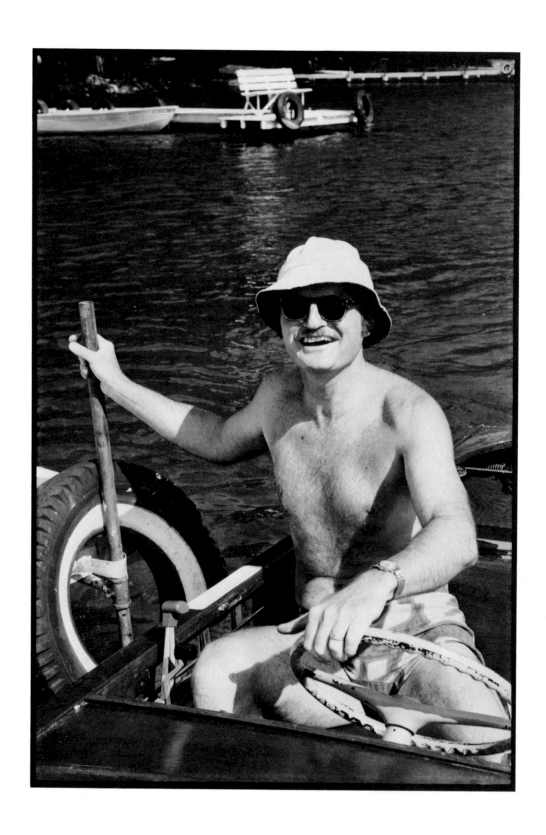

JOHN BARTH
Lake Chautauqua, New York, 1972

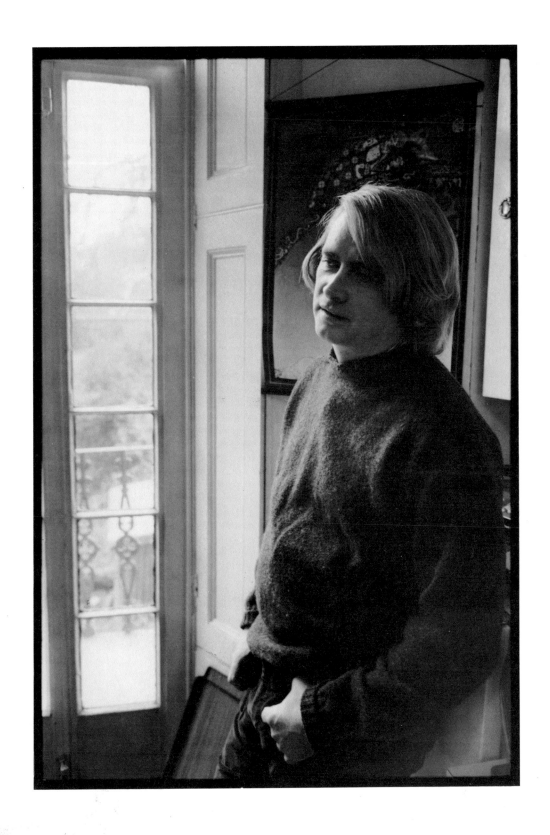

JOHN GARDNER

London, 1971

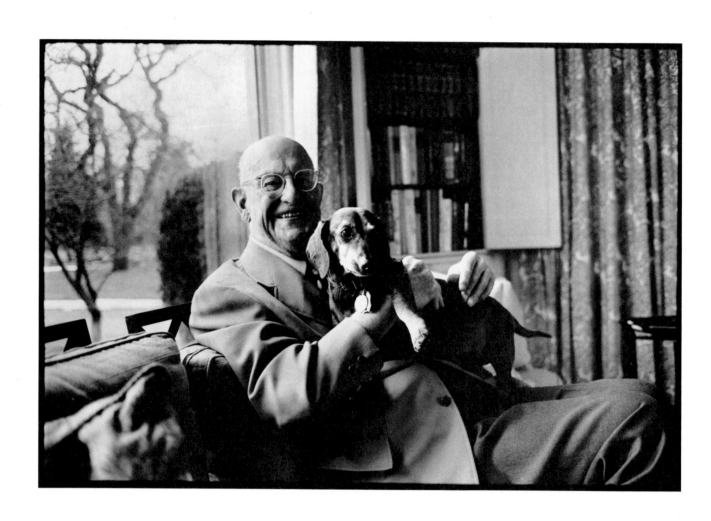

P. G. WODEHOUSE

Remsenberg, Long Island, 1973

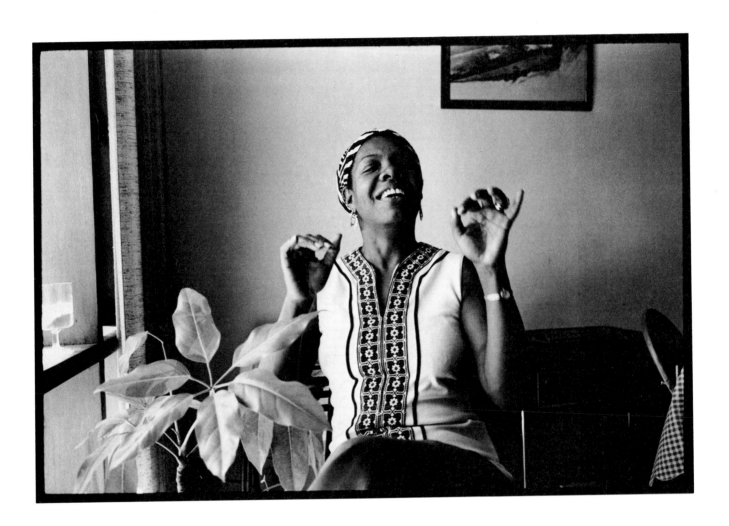

MAYA ANGELOU
Wichita, Kansas, 1975

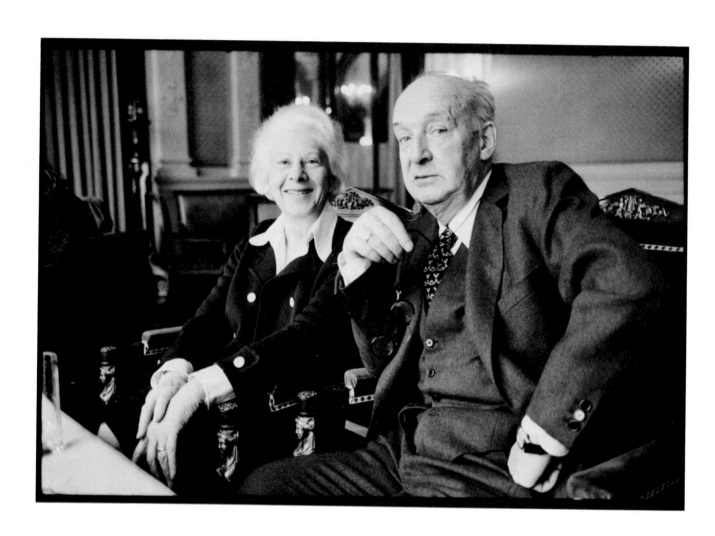

VERA & VLADIMIR NABOKOV

Montreux, Switzerland, 1973

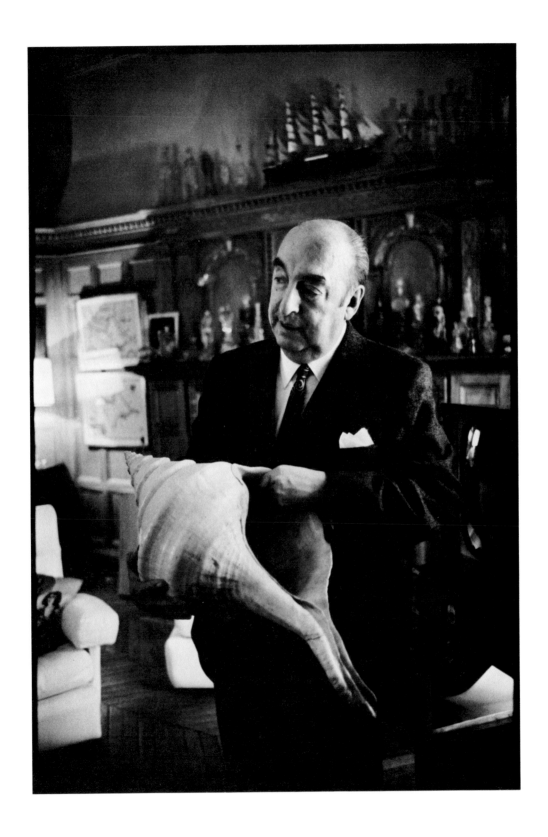

PABLO NERUDA
Paris, 1972

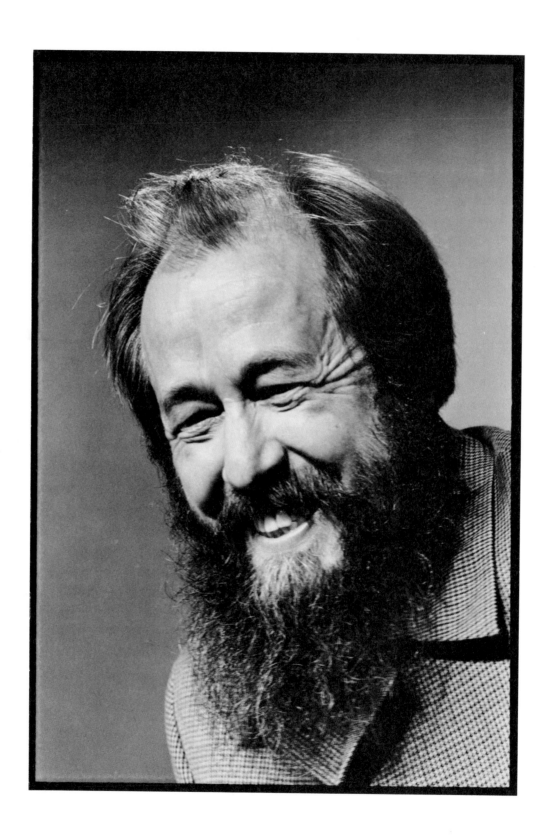

ALEKSANDR SOLZHENITSYN
New York City, 1975

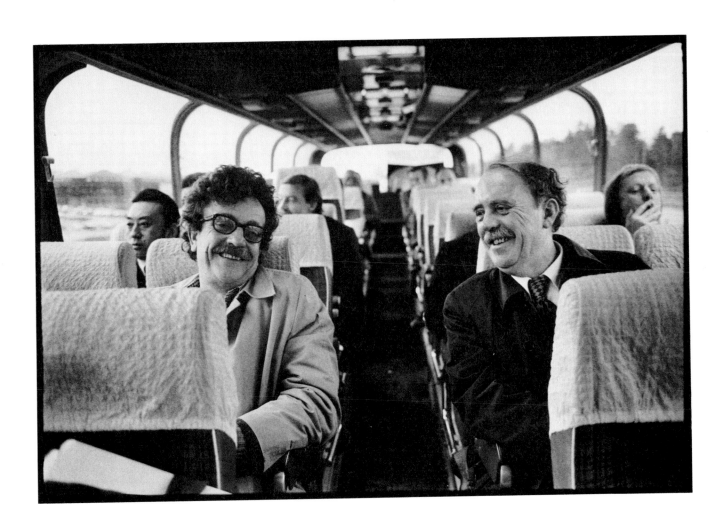

KURT VONNEGUT & HEINRICH BÖLL

Stockholm, 1973

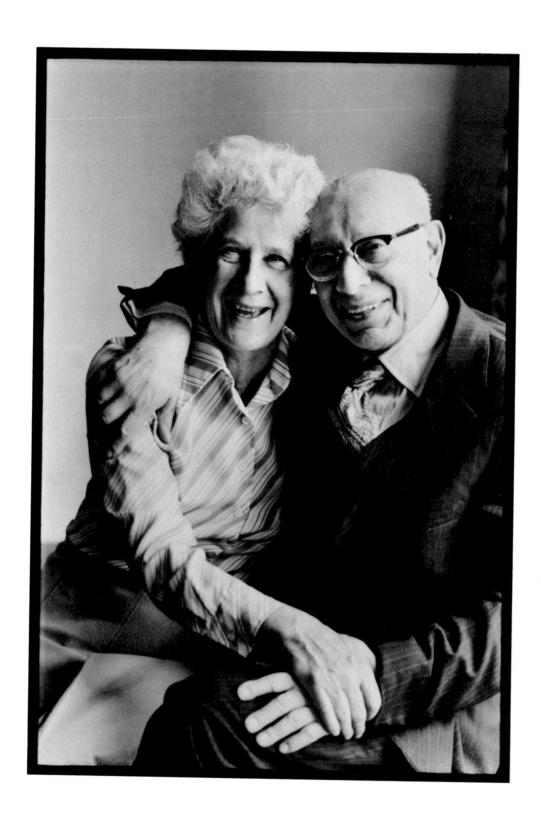

GERTRUDE & BRUNO BETTELHEIM

Portola Valley, California, 1975

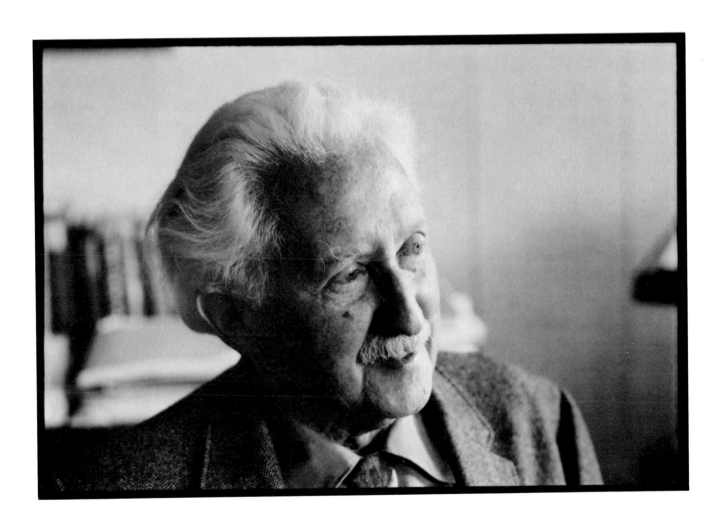

ERIK ERIKSON
Tiburon, California, 1975

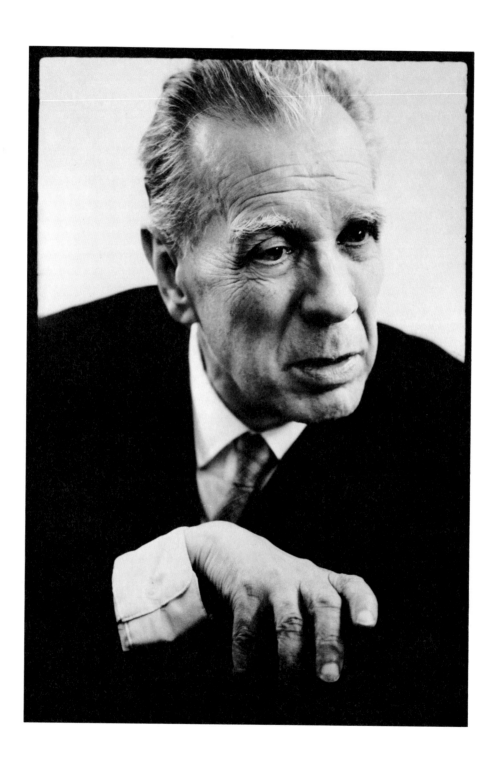

JORGE LUIS BORGES
New York City, 1968

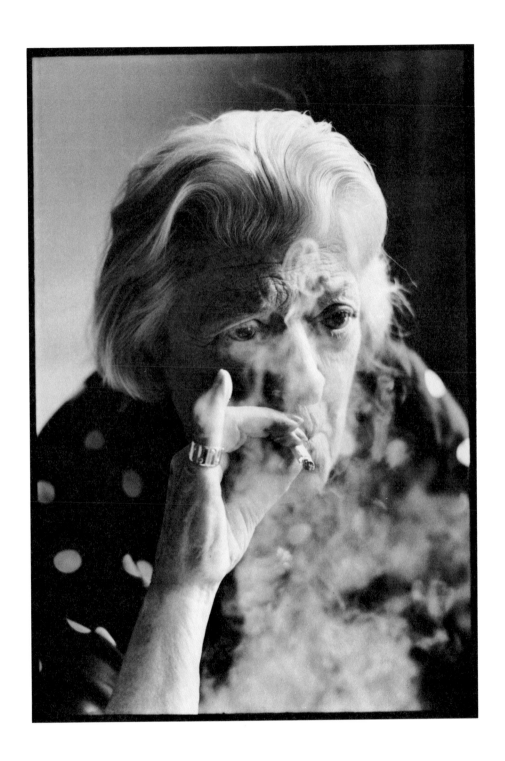

JANET FLANNER
New York City, 1975

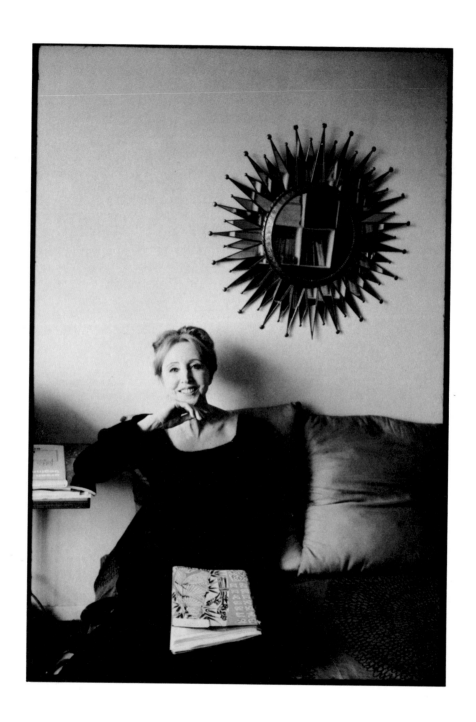

ANAÏS NIN
with her diary
New York City, 1971

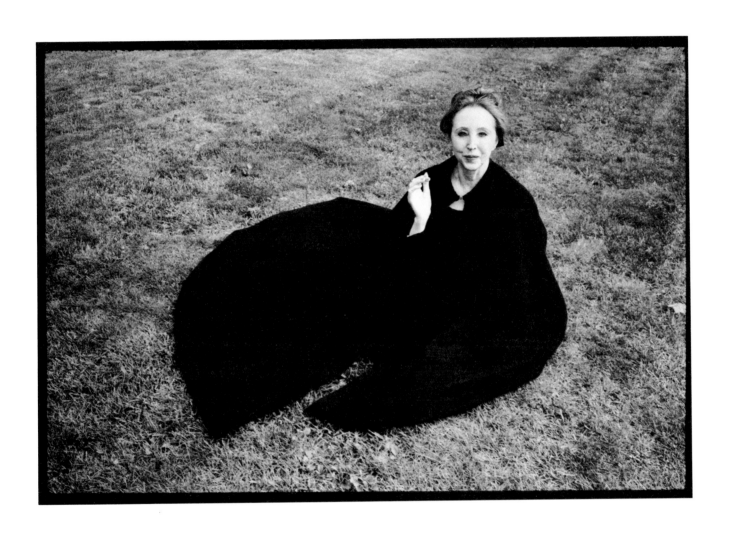

ANAÏS NIN

Washington Square Park, New York City, 1971

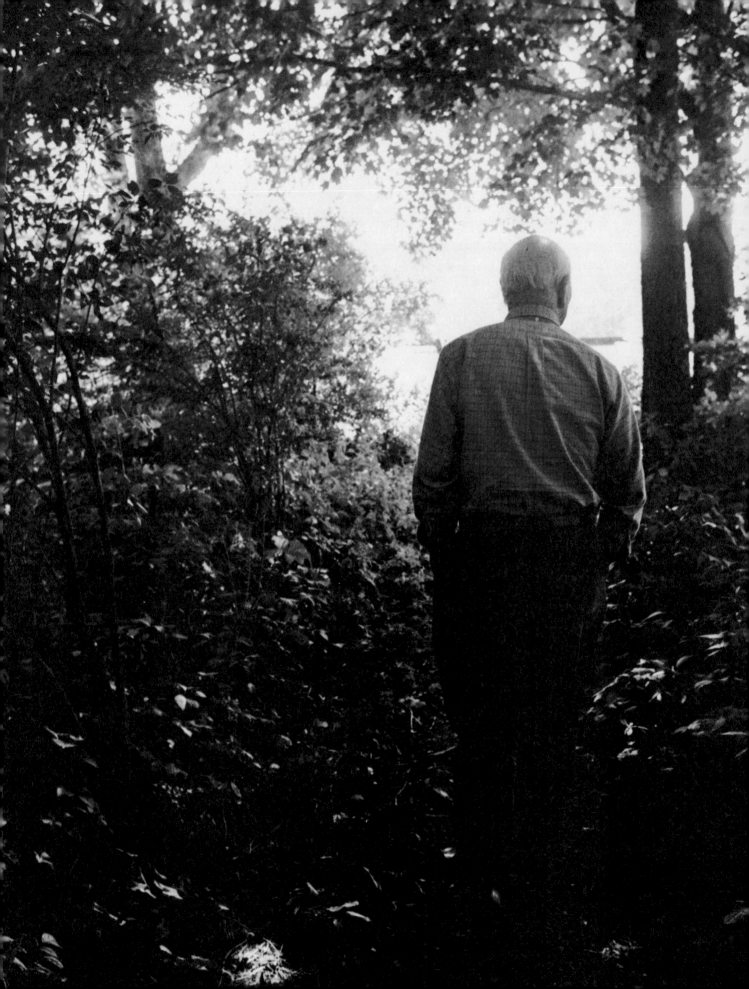

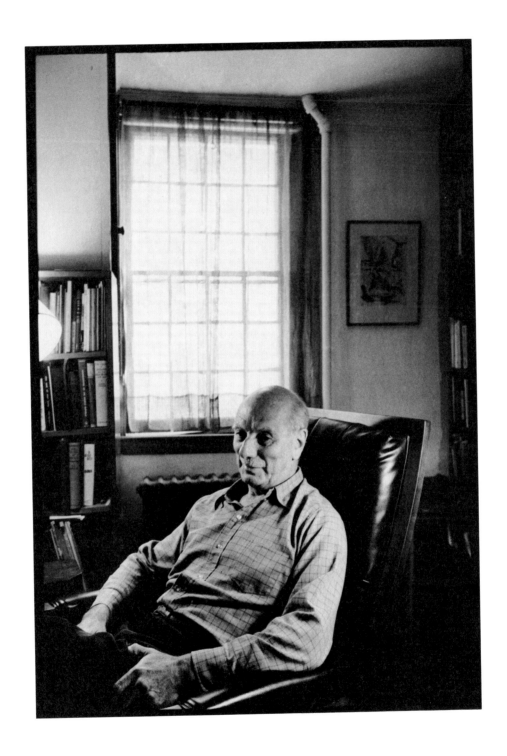

Opposite:
LEWIS MUMFORD
Amenia, New York, 1971

LEWIS MUMFORD
Amenia, New York, 1971

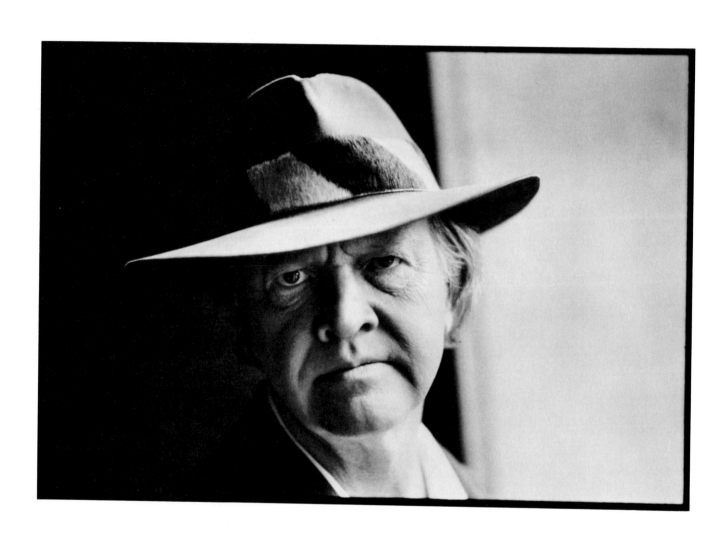

JAMES DICKEY
New York City, 1968

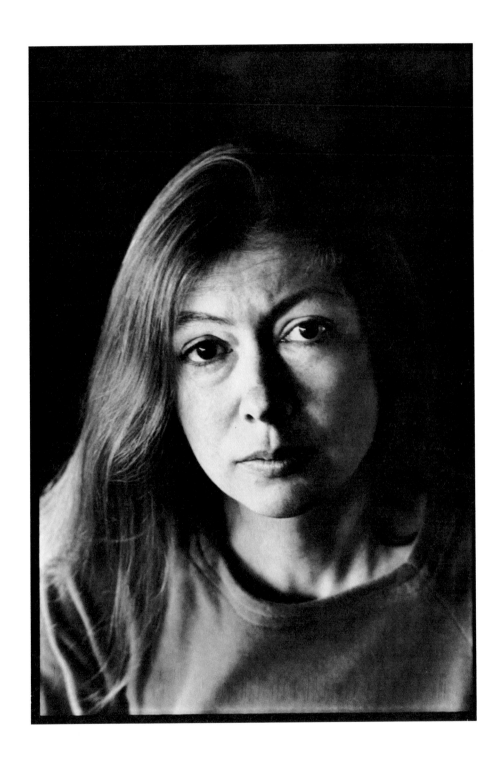

JOAN DIDION
Malibu, California, 1972

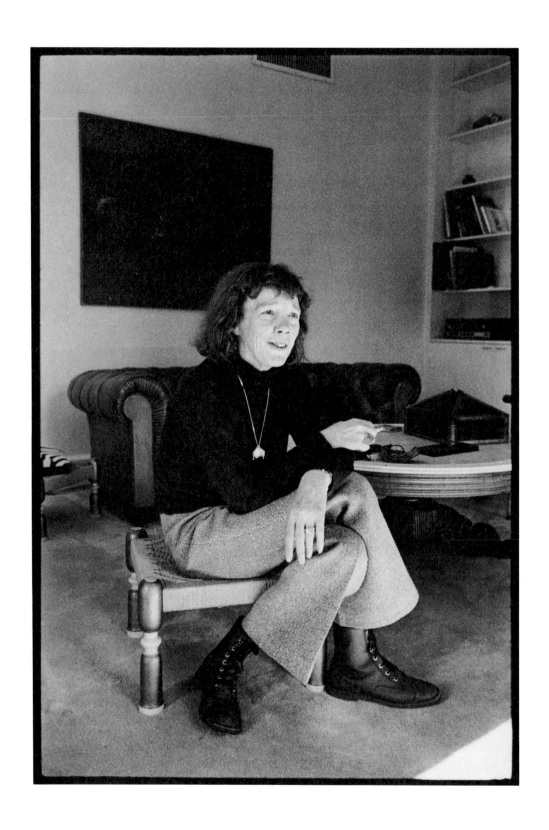

JEAN STAFFORD
New York City, 1971

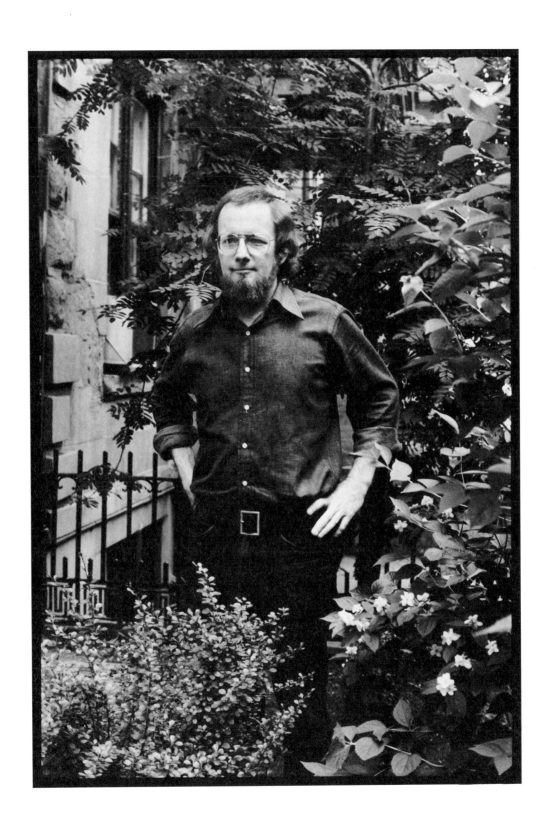

DONALD BARTHELME
New York City, 1972

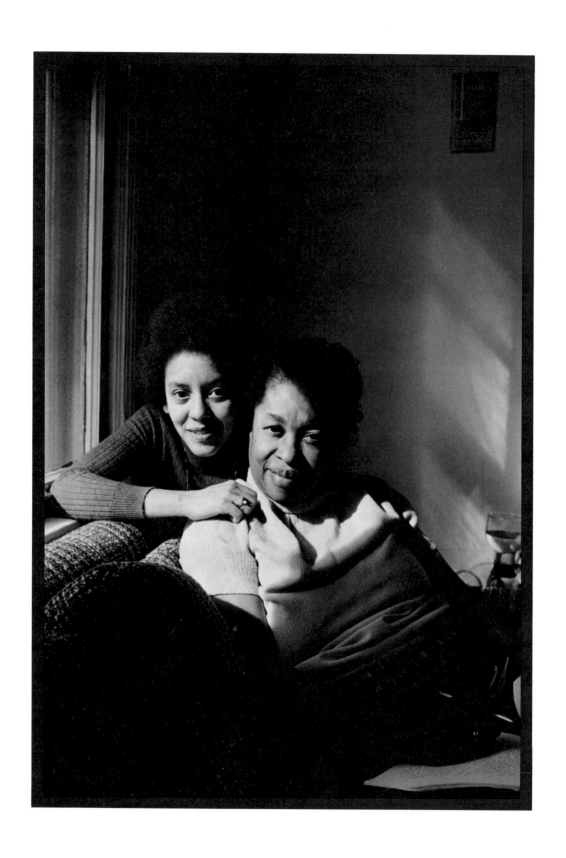

NIKKI GIOVANNI & MARGARET WALKER

Washington, D.C., 1973

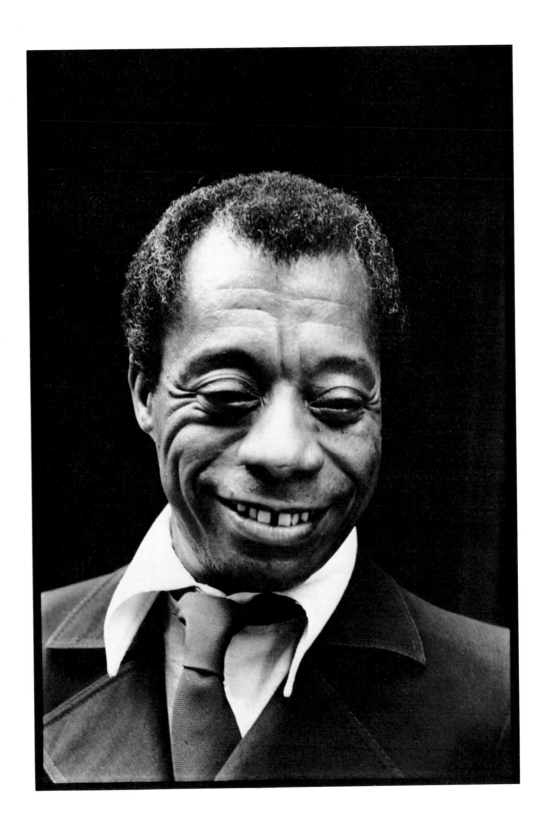

JAMES BALDWIN
New York City, 1973

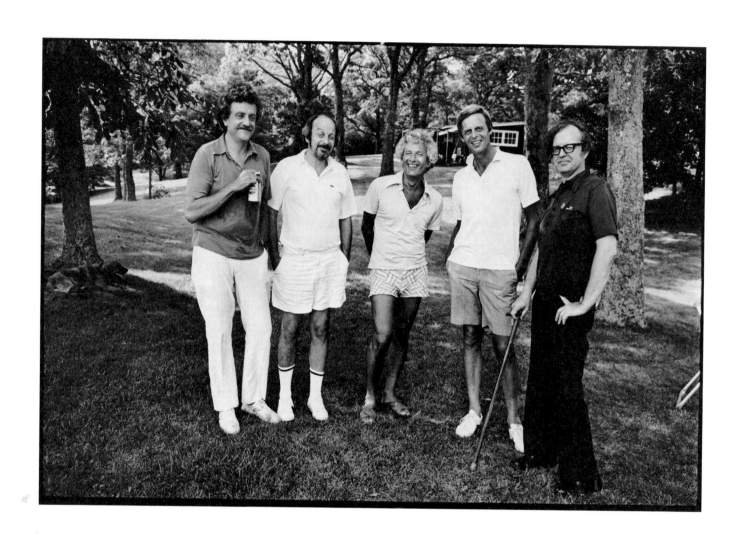

KURT VONNEGUT, E. L. DOCTOROW, JOSEPH HELLER,
GEORGE PLIMPTON & WILFRED SHEED

East Hampton, Long Island, 1975

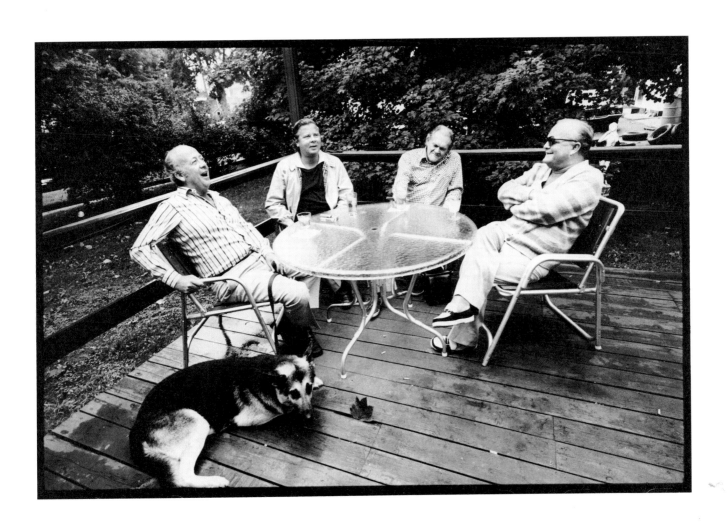

JOHN KNOWLES, WILLIE MORRIS,
JAMES JONES & TRUMAN CAPOTE

Bridgehampton, Long Island, 1975

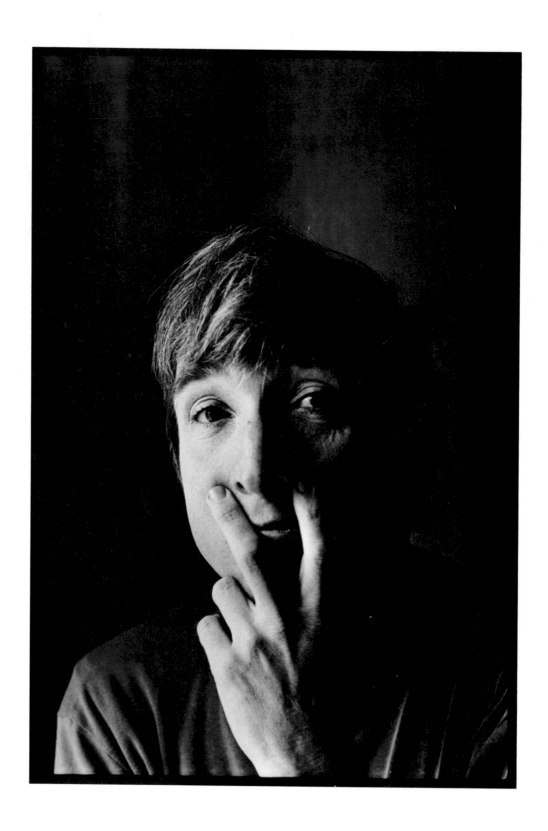

JOHN UPDIKE
Boston, Massachusetts, 1975

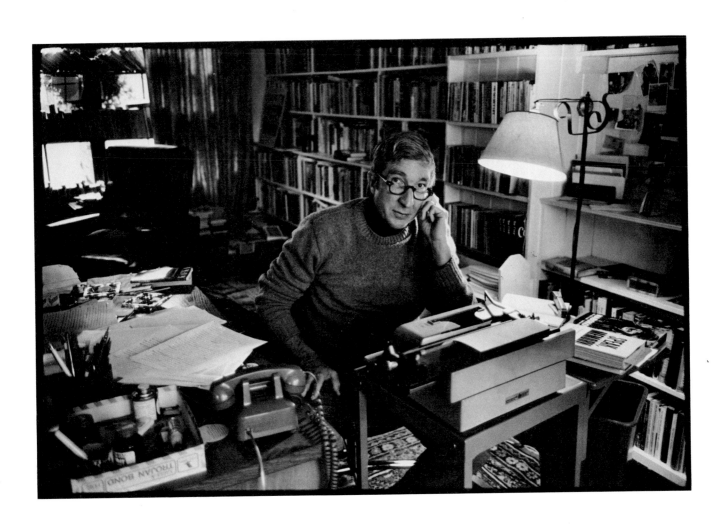

JOHN UPDIKE
Georgetown, Massachusetts, 1979

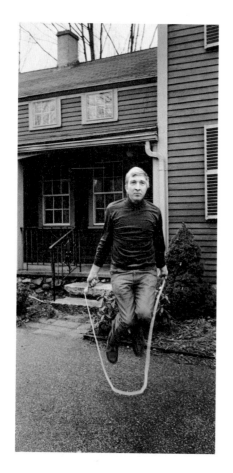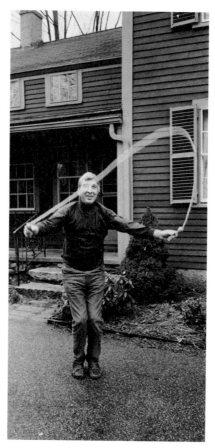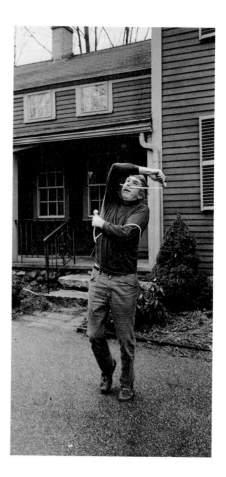

JOHN UPDIKE
Georgetown, Massachusetts, 1979

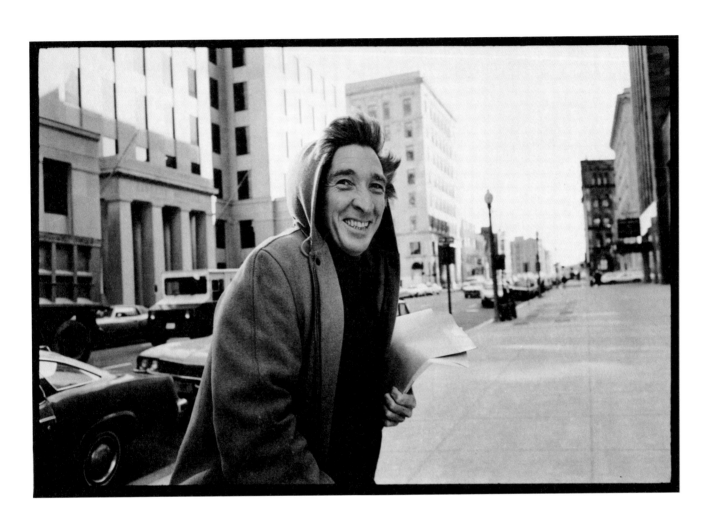

JOHN UPDIKE

Boston, Massachusetts, 1975

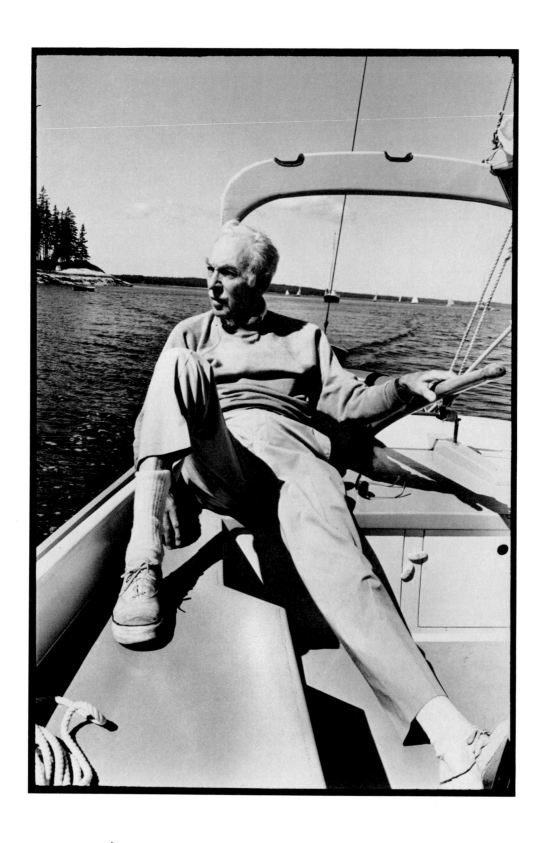

E. B. WHITE

North Brooklin, Maine, 1976

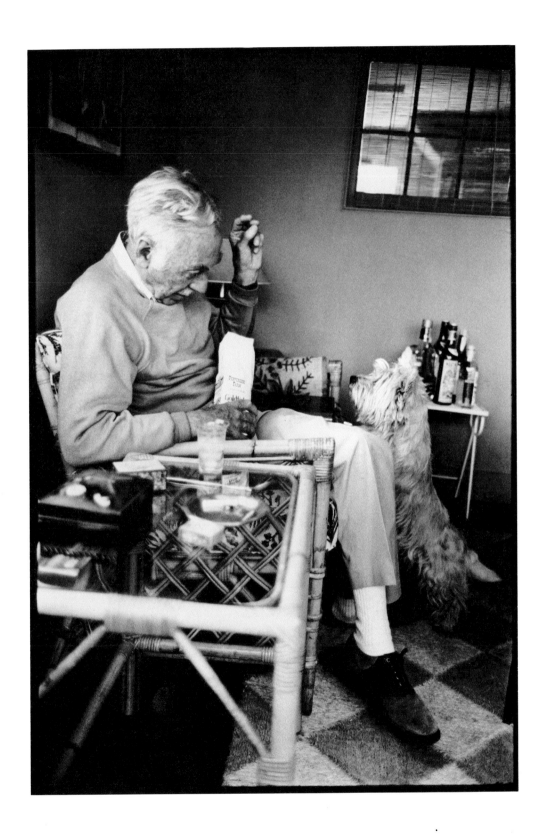

E. B. WHITE

North Brooklin, Maine, 1976

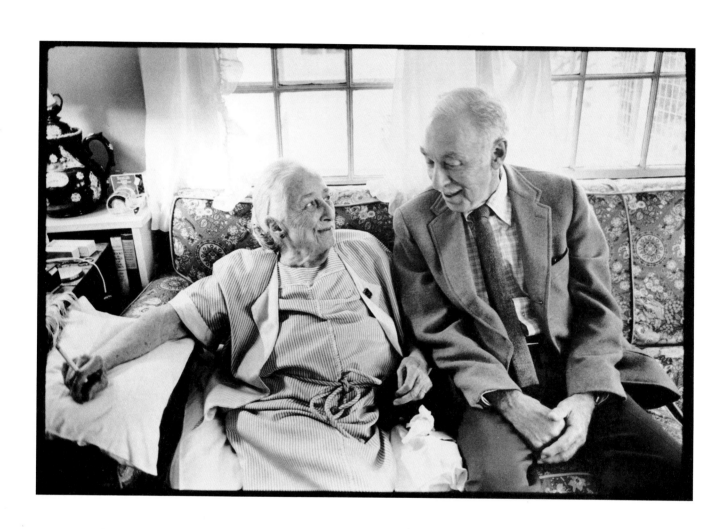

KATHERINE & E. B. WHITE

North Brooklin, Maine, 1976

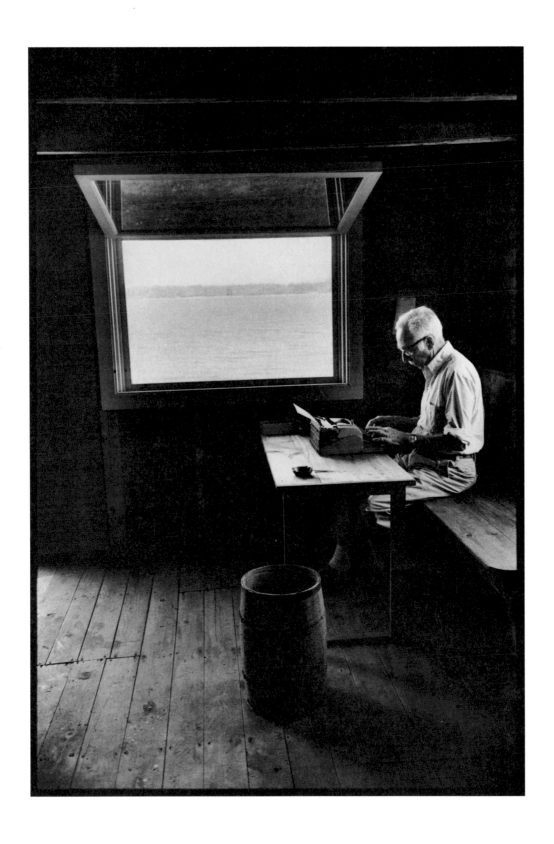

E. B. WHITE

North Brooklin, Maine, 1976

The Writer's Image
has been designed by Katy Homans.
The type, Linoterm Sabon, was set by Bob McCoy/Booktypes.
The book was printed by Dynagraf, Inc. on Warren's Patina
and was bound by Robert Burlen & Son.